IMAGES
of America

GULFPORT

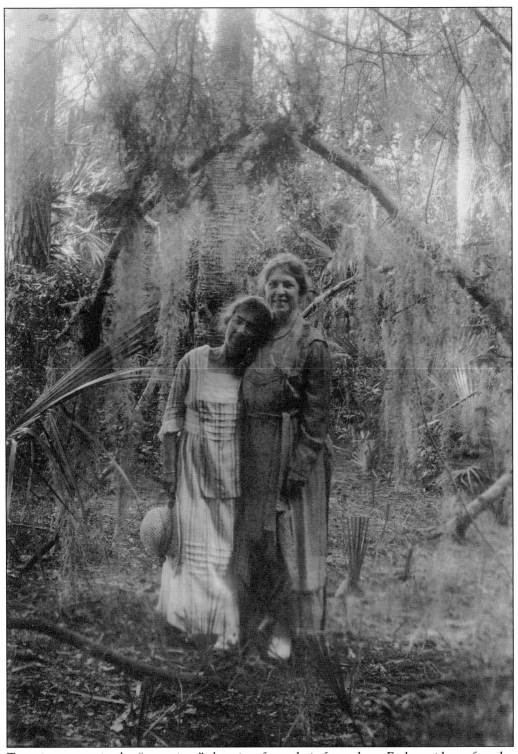

Two sisters pose in the "gray vista," the view from their front door. Early residents found a virgin native growth of pine, palmetto, and Spanish moss.

IMAGES
of America

GULFPORT

Lynne S. Brown

ARCADIA
PUBLISHING

Published by Arcadia Publishing
Charleston, South Carolina

Printed in the United States of America

Library of Congress Catalog Card Number: 99065057

For all general information contact Arcadia Publishing at:
Telephone 843-853-2070
Fax 843-853-0044
E-mail sales@arcadiapublishing.com
For customer service and orders:
Toll-Free 1-888-313-2665

Visit us on the Internet at www.arcadiapublishing.com

*To the memory of Catherine Hickman, who gave so much to Gulfport.
Without her foresight in founding the Gulfport Historical Society,
this story would have been lost forever.*

CONTENTS

ACKNOWLEDGMENTS

The Gulfport Historical Society exists thanks to some very dedicated people, especially Judy Ryerson, Lum and Mary Atkinson, Frances Purdy, and our many other volunteers. Archiving these photos could not have been accomplished without the help of Carole Chapple and Keith Hickman. Our deepest gratitude to all those who donated or loaned photos for this book, to my friends Jan Dutton, Baron Smith, and Miki Vaughan for their comments, and above all, to Nathan White, who has lived the last 75 years of Gulfport's history and remembers every minute of it.

INTRODUCTION

In today's Florida of strip malls and mega attractions, there is little perception of our state as part of the American frontier. The folks who settled Gulfport were truly pioneers, moving away from lives disturbed or destroyed by the Civil War and its aftermath, into uninhabited tracts of virgin pine and palmetto scrub.

Here, an isolated bluff surrounded by tidal flats and bayous beckoned hardy families seeking a place to begin anew. The earliest settlers came from two widely different cultures. Some were hard-working dirt farmers, slow and steady, whose ancestors had moved gradually down through the Southern states, the Carolinas, Georgia, and North Florida, raising families on the small plots of land they cultivated. Others were bold sailing men who traced their descent from Bahamian wreckers and Key West adventurers, whose only homes had been their fleet little boats.

From these beginnings, a small thriving fishing village grew up, isolated from the rest of the world except by sea, facing and surmounting disasters both natural and man-made. Hurricanes swept away the docks, the hoped-for railroad never arrived, and the settlement dwindled. Then came the early entrepreneurs, with their electric streetcar line and plans for a grand, almost utopian, community. While the 50,000 homes along fine boulevards never materialized, the trolley soon brought a new kind of prosperity: the tourist. It was now possible to travel from Tampa to St. Petersburg and on to Gulfport, where one could disembark by boat for the beaches.

The 1920s were boom times in Florida. The magnificent Rolyat Hotel, the very epitome of the new Mediterranean Revival architectural style, was the centerpiece of local development, but everywhere in the town homes and businesses sprang up to meet the demands of the burgeoning population. The Depression hit here, too, of course, closing the Rolyat, halting planned municipal projects, and again slowing Gulfport's growth and prosperity.

As the economy recovered in the late 1930s, Gulfport found itself more than ever before an important winter destination for wealthy northerners who created an interesting contrast as they fished along the new pier beside the rugged locals or played bridge on manicured lawns almost across the street from rowdy taverns. The rebuilt Casino and the charming Boca Ciega Inn, and the shops and restaurants all entertained a steady flow of visitors who came for their piece of paradise.

Once again harsh realities of the outside world caused the dream to die. The war years show us a microcosm of small-town America: a community drawing into itself, at first highly opposed

to foreign intervention, and later supportive of the war effort nearly to the point of jingoism. All the boys who grew up here were sailors almost from birth; when the war came, every member of the local sailing club enlisted. The town rallied in complete support of their heroes, and heroes they were, including the young pilot about whom was written the song, "Comin' in on a Wing and a Pray'r."

The 1950s brought a huge residential expansion. Air conditioning became more available, returning servicemen needed homes for their young families, and retirees flocked to buy into the mild climate and economical living. Still, the city retained an unusual, if not unique, sense of "place," a strong individualism that has become only stronger through the ensuing decades. Today, Gulfport attracts artists and writers, refugees from totalitarian regimes, and people of disparate lifestyles—a citizenry dedicated to preserving a kind of history and culture rarely seen at the end of the 20th century.

People of Gulfport now and in the past have always loved this place with unabashed emotion. It shines through these pages and lights our lives as we move into the future.

–Lynne S. Brown

One

BEFORE 1910

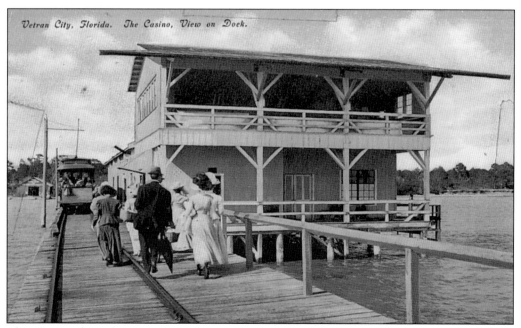

Vetran City, Florida. The Casino, View on Dock.

The Casino has always been the heart and soul of Gulfport. After the streetcar from St. Petersburg began running in 1905, this building was constructed to provide a waiting place for passengers connecting with boats to Pass-a-Grille. Called the "Dock and Spa," the Casino opened January 14, 1906, with a dance hall on the second floor above a refreshment stand. Though planned as a stopover, it soon became a popular destination in itself.

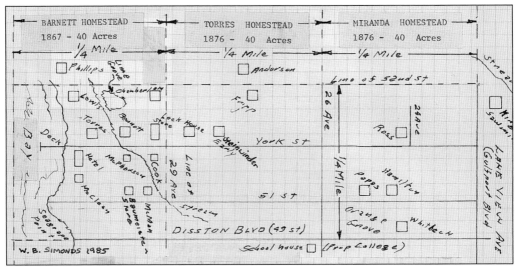

The first settlers arrived shortly after the Civil War. James and Rebecca Barnett homesteaded the bluff now at the foot of Fifty-second Street, where they built a home, planted crops, and eventually sold their improvements to Joseph Torres, who came here in 1876 from New Orleans. William Miranda's family had earlier settled elsewhere on Point Pinellas. He built here c. 1883, developed a real estate business, and worked as a surveyor.

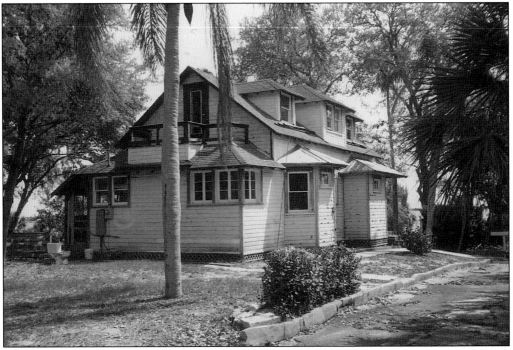

The oldest house still standing in Gulfport once belonged to Joseph Torres, a Spaniard who had been with Maximilian in Mexico. Torres arrived in 1876 with both the money and enthusiasm to build a town. His general merchandise store was housed in this building, which has been moved from its original location and extensively remodeled since this 1992 photograph. Built by Vincent Leonardy, another early settler, the building served as a post office and residence for Torres as well.

10

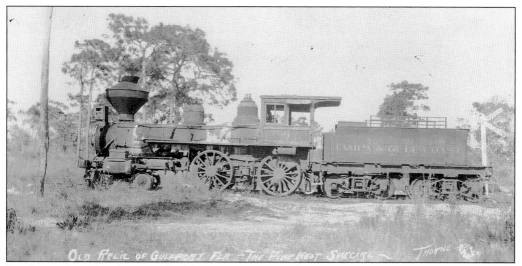

By the mid-1880s, the town had begun to grow, and the lumber industry was expanding to provide materials for building. This picture shows the Pine Knot Special, a wood-burning train, near George King's sawmill in 1887. The virgin pine forests of the lower peninsula were being harvested as land was cleared for farming and cattle grazing.

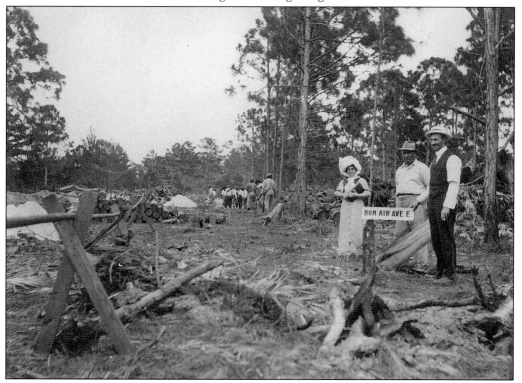

Early settlers opened trails through the Pinellas wilderness to provide for the movement of cattle and crops to ports for shipment to Tampa and Cuba. Road clearing began when speculators offered lots for sale and needed to provide some means of access to them. Here, workers clear Bon Air Avenue, which later became Thirtieth Avenue South, between Fifty-fourth and Fifty-eighth Streets.

The coming of the streetcar line in 1905 brought the first real growth to the area. Now not only did passengers arrive to take boats for the Gulf beaches and other destinations, the farmers and fishermen had an efficient way to get their products to markets. The system was far from perfect, with many power failures and long delays, and the schedule, always flexible, depended on the number of operable cars in service.

Roads were opened beside the tracks. These were still only rough trails, with no bridges over the many streams, so the journey between settlements, whether on foot or horseback, was still a long and difficult one. Today's Tangerine Avenue was one of the first to be opened, followed by Beach Boulevard.

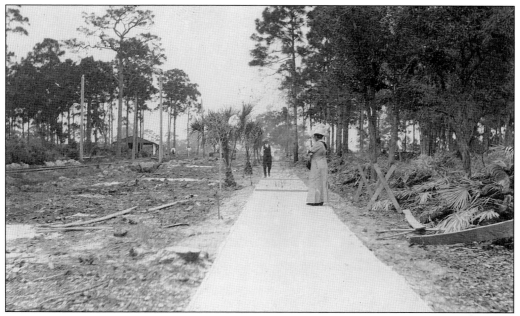

This is a view looking north on Beach Boulevard from around 1909, showing the clearing of land along the east side of the tracks. The lady stands on the town's first sidewalk, which ran about 75 feet south of Twenty-eighth Avenue.

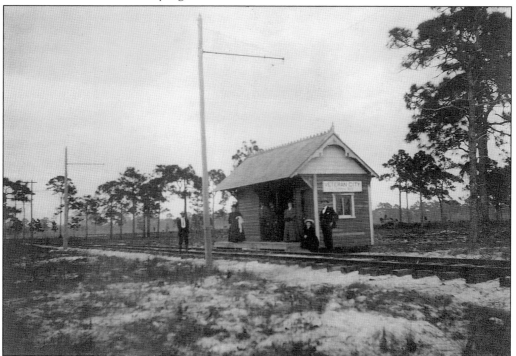

The Veteran City train stop in 1908 was located on the east side of the car line at Twenty-seventh Avenue. This was the original southern terminal, until the tracks were extended along a wharf out into the water to the Casino, eliminating the long walk through mud flats to meet boats at the dock.

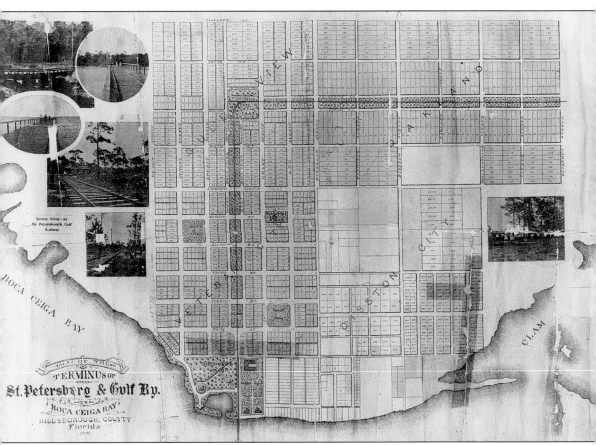

Until the arrival of Hamilton Disston in 1884, the town was essentially a nameless settlement. Disston, who had inherited a Philadelphia manufacturing business, was a millionaire who had first come to Florida for sport fishing, but soon was taken with the idea of a tropical empire. Florida was in poor financial condition at the time, and Disston's offer to buy some four million acres was readily accepted. This purchase included a good part of the Pinellas peninsula, and thanks to the encouragement of William B. Miranda, Disston made his headquarters here. He laid out a plan, seen in this 1905 map, for a grand city, with broad boulevards and parks. Though none of this materialized, he did build a wharf, warehouse, homes, and stores, as well as the elegant but short-lived Hotel Waldorf.

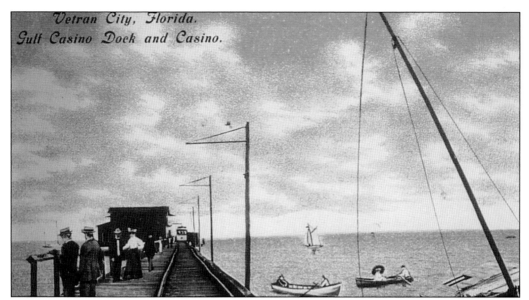

Vetran City, Florida.
Gulf Casino Dock and Casino.

Disston City, as it had become known, was too similar to the name of another town, so it became Bonifacio, after William Bonifacio Miranda. Residents complained that their mail too often ended up in Cuba. In 1890, the other Diston was abandoned, and the Disston City name was resumed until 1906, when John F. Chase came along and planned a subdivision on the site, to be called Veteran City, here misspelled "Vetran."

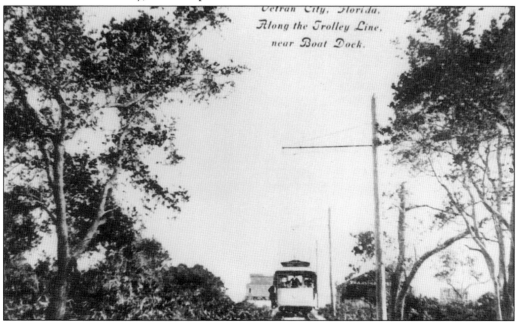

Vetran City, Florida.
Along the Trolley Line,
near Boat Dock.

Veteran City received its new name at the dedication ceremony for the opening of the streetcar line in 1905. Chase, a Union veteran, advertised widely his planned ideal community for retired servicemen, but the venture was not successful. The area was still too remote and undeveloped to attract much settlement. Together with Hamilton Disston, however, Chase had succeeded in providing the one element that would contribute to future growth, and that was the trolley service.

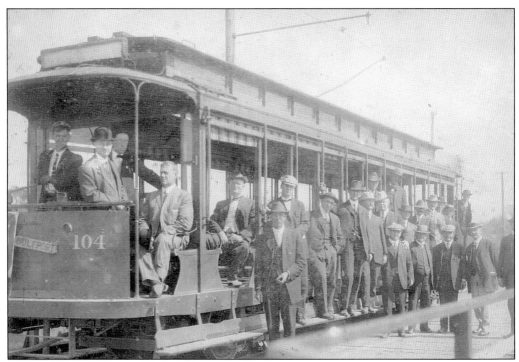

The first trolley run, seen here, attracted a number of dignitaries invited to the Veteran City dedication ceremonies. These early cars were of the open, nine-bench style, which gave passengers little protection from rain and mosquitoes during the frequent breakdowns in electrical service.

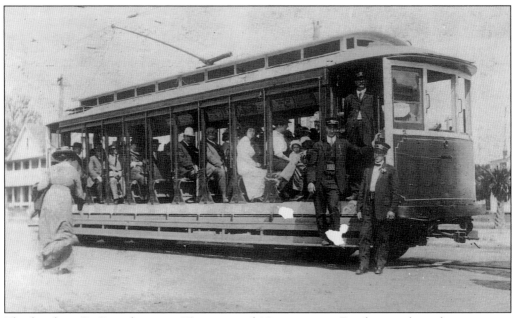

The fare from St. Petersburg was 15¢ going and 10¢ returning. For those making the entire trip from Tampa to St. Petersburg (by boat), from St. Petersburg to Veteran City (by streetcar), and from there to Pass-a-Grille (again by boat) and back, the advertised fare was $1.50.

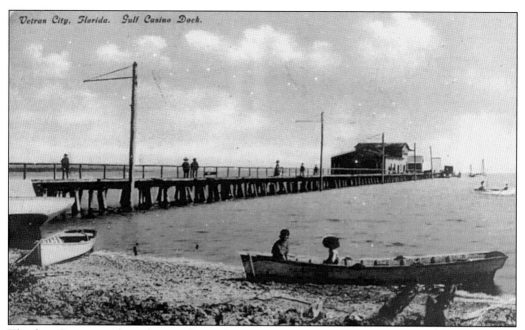

Vetran City, Florida. Gulf Casino Dock.

The first Casino, with its famous floor of polished yellow pine, quickly became a favorite dance hall, generating much revenue for the trolley line owners. On weekends the trolleys would line up and wait for the dances to finish to transport partygoers back to St. Petersburg. A walkway for pedestrians can be seen along the left side of the dock in this old postcard.

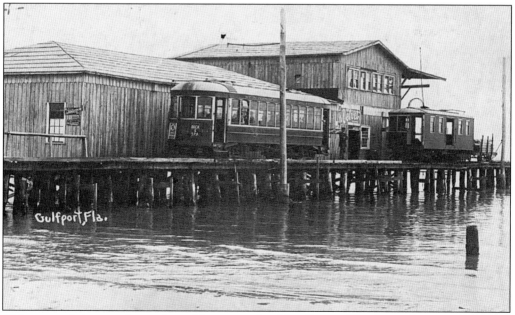

Gulfport Fla.

This postcard shows a closer view of the west side of the Casino. The dance floor was located in the second story, which was open to the water on the south. Both building and car tracks were on pilings, and the roof trusses were of 4- by 12-inch pine, bolted together in a complex pattern that required the bolts be hand-fashioned by a blacksmith right on the building site.

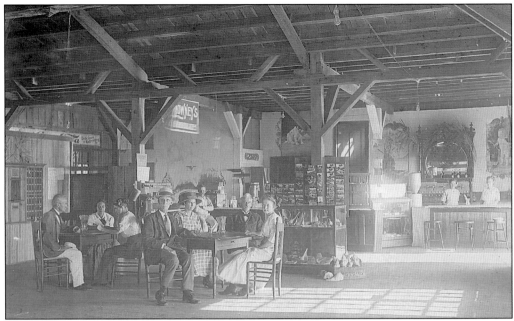

The refreshment stand on the east side of the Casino sold drinks, tobacco, and souvenirs. The T.C. Roberts family, who managed the concession stand, also had living quarters in the building. Note the complex beam structure of the roof.

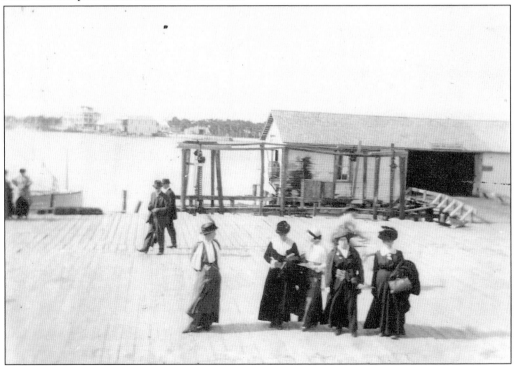

The tracks went past the west side of the Casino to the end of the dock, where there was a passenger platform. Soldiers departed and returned here for duty at Fort Dade on Egmont Key, but in this picture, a group of well-dressed ladies is out for an excursion to Pass-a-Grille.

Singlehurst's sawmill was built in 1907 at the corner where the streetcar line turned south down Beach Boulevard from Tangerine. A narrow-gauge railroad ran northwest from the sawmill toward present-day Fifty-eighth Street and Fifteenth Avenue. This rail was used to haul logs from the woods and had no connection with the car line.

The sawmill was in operation for about three years, until all the nearby trees were cut and sawed. Originally covered in large virgin pine, this area provided millions of feet of lumber. Many Gulfport houses were built of that pine, and stand today, the wood hardened over the years and impervious to decay or insect damage.

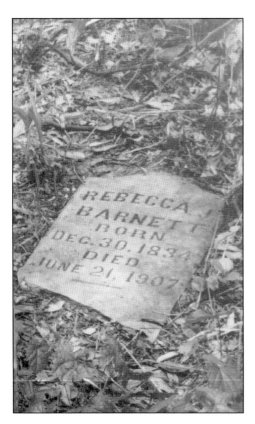

Rebecca Jane Arnold Slaughter Barnett died in 1907 after a fall in her home. This pioneer woman was literally the "Eve of Gulfport," leaving seven children and their descendants to build the city. Her broken tombstone was found in the Glen Oaks Cemetery in St. Petersburg, a small graveyard once owned by her older son, Henry Slaughter. The cemetery is now in a state of almost total disrepair. With her passing, the pioneer era was over.

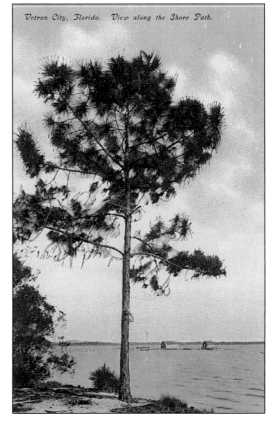

After only five years, the Veteran City era was fading into the sunset, too, as the call went out for all registered voters of this area to meet for the purpose of establishing a municipal government. The residents also planned to take on yet another name, hopefully one that was more descriptive of the growing young community.

Two

1910–1920

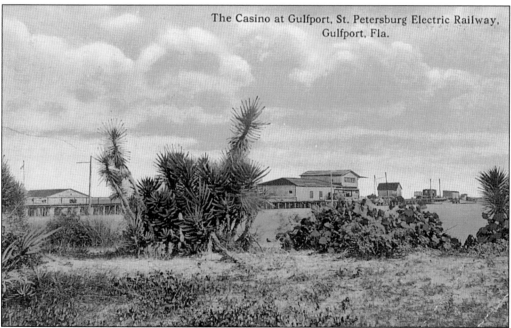

The Casino at Gulfport, St. Petersburg Electric Railway, Gulfport, Fla.

The Casino remained a central gathering point throughout the decade of 1910 to 1920, and it was where 30 of the 38 registered voters met to incorporate the town of Gulfport on October 12, 1910. The new council soon drafted an ordinance establishing prohibition a full decade ahead of the rest of America, a sentiment echoed by the sender of this postcard, who wrote, "No corn, no whiskey allowed in this part of the country."

The seal and motto of Gulfport were adopted at the time of incorporation. The Reverend Alonzo A. Hoyt presided over the meeting and presented his design for the seal, which is still in use today. The drawing shows the *Gypsy*, which had provided ferry service to the beaches since 1903. The rest of the design seems an imaginary view of the future.

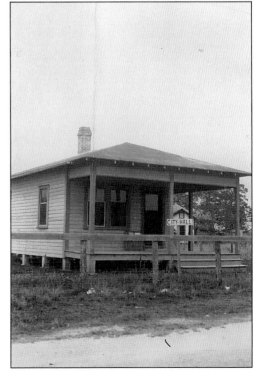

Early council meetings were held at the Casino or in temporary "city halls" such as this. Elmer E. Wintersgill was the first mayor, Samuel J. Webb became the town clerk, and John C. White was named marshal. With the four new council members, there was now almost one elected official for every five voters.

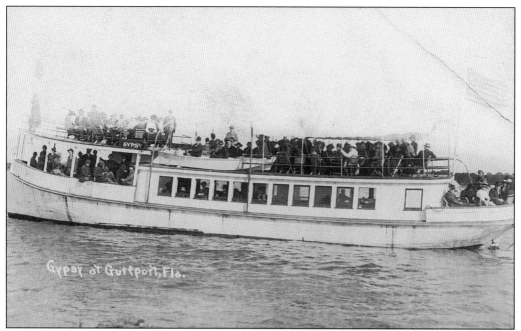

The steamer *Gypsy*, which could carry 180 passengers, replaced an earlier, smaller carrier, the launch *Jenny*. During World War I, official passenger service was discontinued, and although private operators remained active, with a bridge now open, business slowed down. Eventually, *Gypsy* became a party fishing boat and served in that capacity until 1944.

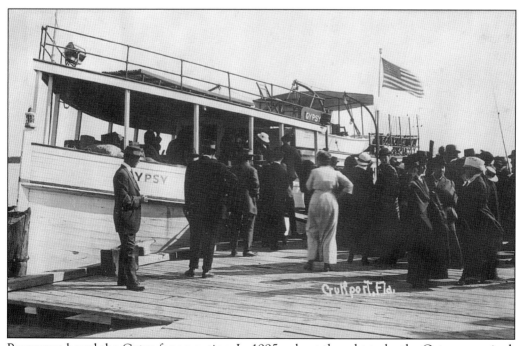

Passengers board the *Gypsy* for an outing. In 1995, a boat thought to be the *Gypsy* was raised, and a campaign was begun to restore it before it was proven to be a different vessel. The true *Gypsy*'s whereabouts remain unknown today.

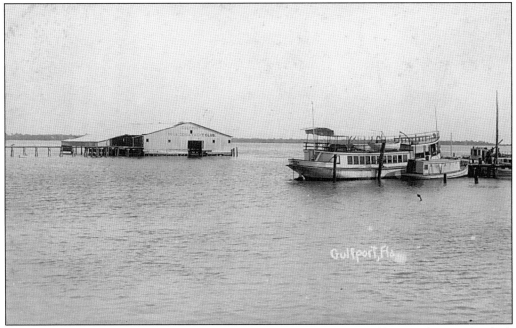

The Boca Ciega Yacht Club was owned and operated by the Wintersgills. Seen here at the dock are the *Gypsy* and the *Joe*, a clammer belonging to Captain Harry Yawger.

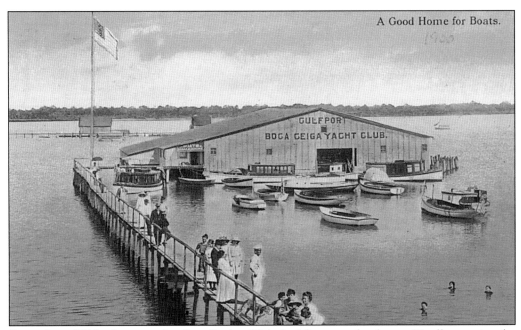

Erected in 1910, this was the first Yacht Club building on the lower Pinellas peninsula. It survived only until 1915, when it was destroyed in a storm. Its exact location in the Boca Ciega Bay is a matter of some speculation today.

The first sea walls, constructed of wood, were put in during this decade, probably about 1913.

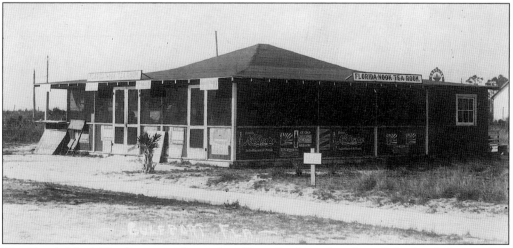

The Florida Nook Tea Room was located on Shore Boulevard at about Fifty-fourth Street, then called Grant Avenue. The back of this postcard notes that they served tea and fish dinners but no liquor.

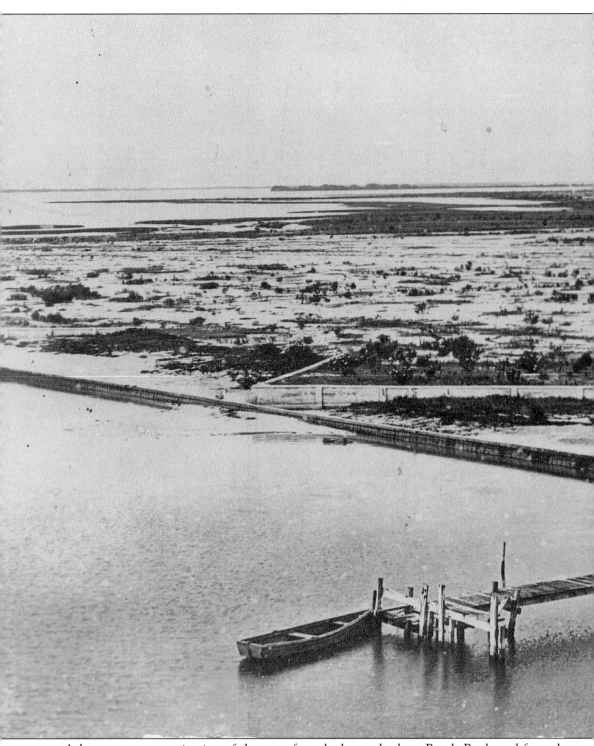

A late teens panoramic view of the waterfront looks north along Beach Boulevard from the Casino. Note the tidal mud flats as far up as the Bay View Hotel, and the pier at left, which was for the use of the hotel guests. The Bay View, built by Malcolm McRoberts probably around

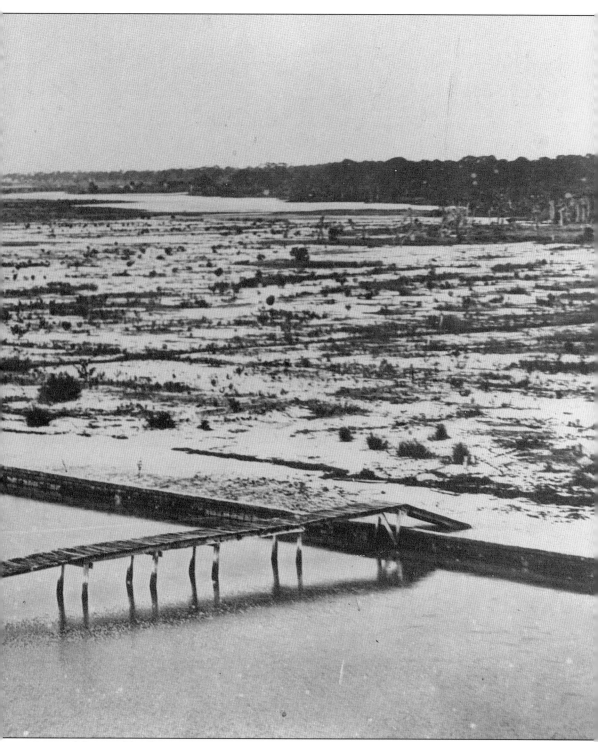

1911 and financed by five stockholders, had its own pumping station and water tower for the convenience of guests. Other town residents still hand pumped water from shallow wells; this water often tasted of sulphur and palmetto roots.

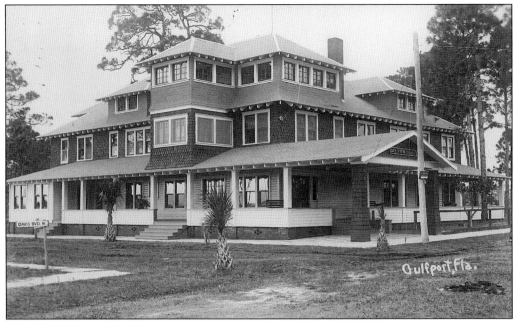

The Bay View Hotel, a three-story, wood-frame structure, was built of the local pine lumber and stands today relatively unchanged, except for the later addition of an elevator. As shown by the road sign, Beach Boulevard was then known as Davis Boulevard. The Bay View was recognized as a local historic landmark in 1996.

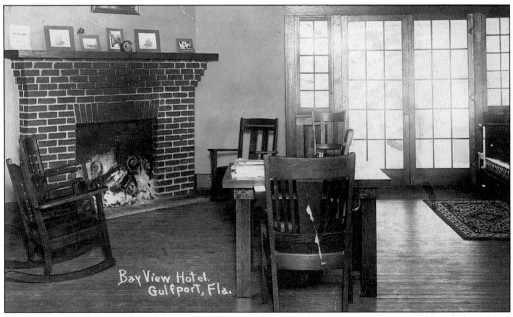

This postcard of the lobby of the Bay View Hotel shows the entrance doors, red brick fireplace, and polished pine floors of this early era. Note also the Mission-style furnishings. In the early 1940s, the hotel was sold and converted to a nursing home.

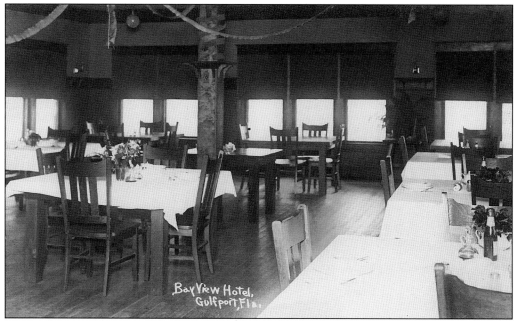

The Bay View's dining room on the south side of the building was one of the town's most popular restaurants for many years. Known as "The Pipin' Hot," it was the site of meetings for local organizations, such as the Women's Club. The restaurant remained open to the public during much of the Bay View's future life as a nursing home, hospital, and rest home.

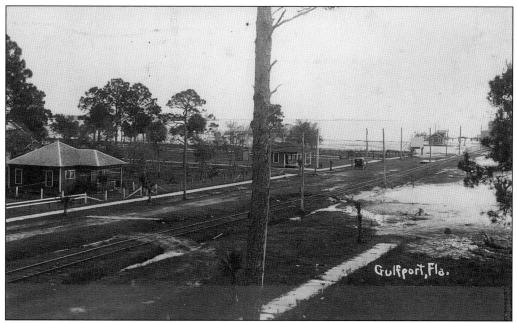

Looking south from the Bay View Hotel, the view down Beach Boulevard shows the street, trolley tracks, and sidewalk completed to the waterfront. The town's first commercial buildings have begun to appear, including the real estate office of Lester Wintersgill (center).

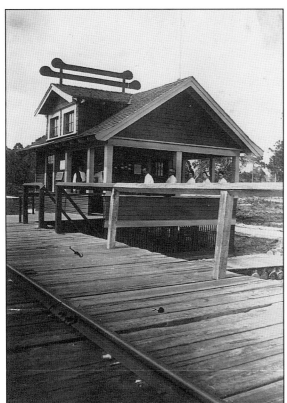

This building, which can be seen at the far right of the previous photo, was located at the water's edge just before the approach to the Casino. It served as a waiting station for transfers from the trolley to a boat.

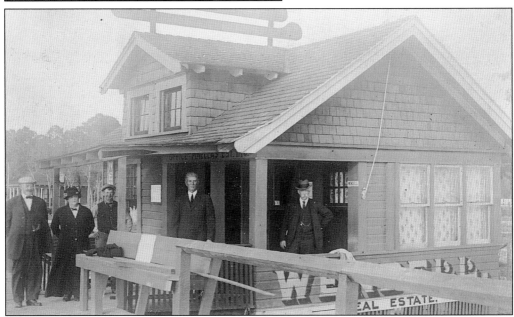

A real estate office soon opened here, after the building was partly enclosed and expanded to house new business ventures. Though this building would be destroyed in the 1921 hurricane, future real estate offices would occupy its site on the corner of Beach and Shore Boulevards throughout most of the century.

Thompson C. Roberts celebrates Christmas on the pier in 1917. His father managed the Casino and refreshment stand, and his mother was one-fifth owner of the Bay View Hotel. Thompson was almost two years old in this photograph and obviously had received a great haul of toys.

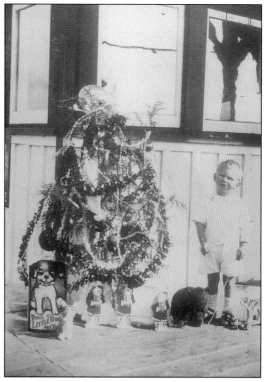

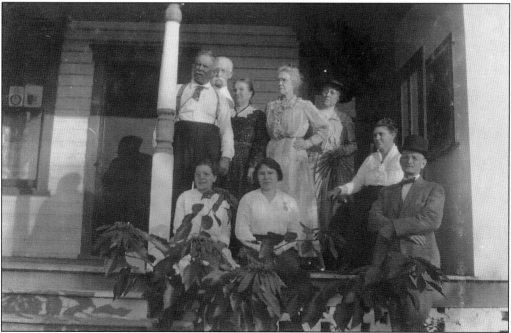

A gathering on the porch of Thompson's uncle, Lester Wintersgill, on Beach Boulevard includes H.G. Hamm, an early mayor, standing at the left. Wintersgill's daughter Elsie Roberts (left) and granddaughter Phyllis Roberts Holland are sitting on the steps. Others in the picture are unidentified.

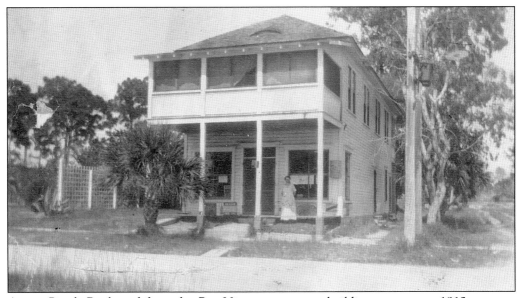

Across Beach Boulevard from the Bay View, a two-story building went up c. 1912 to serve as a grocery store, owned by the Clausen family, who lived upstairs. Later the structure became a toy factory, until it was remodeled in the 1940s as an apartment building, which it serves as today.

The home of Robert and Eva Kuder was located at Beach Boulevard and Twenty-seventh Avenue and is known today as the Camp house. It later became the residence of Mr. and Mrs. Paul Camp, owners of the Boca Ciega Inn. Many of Gulfport's older homes are found in this area, due to its convenient proximity to the side track where the trolley dropped off flat cars delivering building materials.

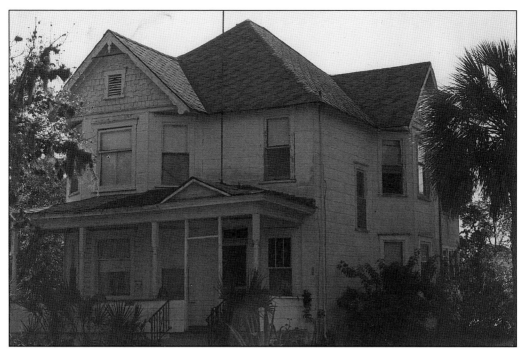

This Queen Anne-style house, also on the corner of Beach Boulevard and Twenty-seventh Avenue, was built around this period. Known as the Sackrider-Cronkhite house for the family of early owners, it is associated with John Cronkhite, a World War II hero and inspiration for the song "Comin' in on a Wing and a Pray'r." Badly deteriorated in this 1979 photo, the home is currently being restored.

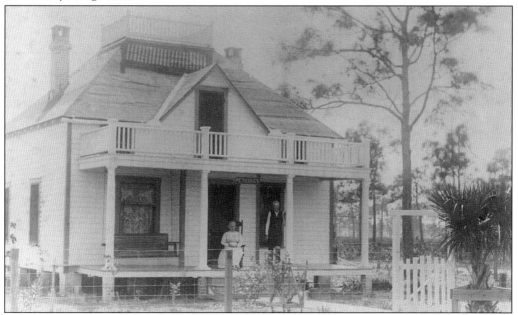

No longer standing, the Stowell House was once located on the southeast corner of the Tangerine and Fifty-second Street intersection. The widow's walk is an unexplained feature in this neighborhood, some 15 blocks from the water.

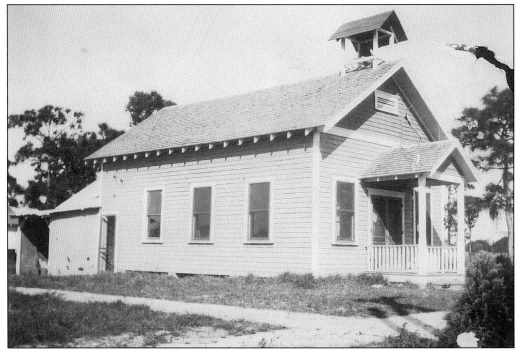

The first Gulfport City Hall was built in the "early Orange Belt depot" architectural style in 1913 for a cost of $1,259.75. Constructed by C.C. Sawyer, the hall stood in Chase Park approximately where the shuffleboard courts are now. It was funded by proceeds from the first municipal bond issue and was painted yellow.

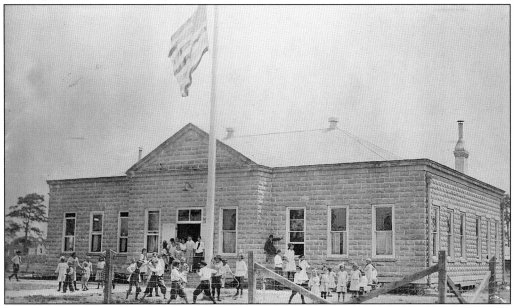

Gulfport Elementary School's first home was described by a contemporary as an "artistic stone building, with four large airy light rooms, extensive playgrounds and gardens." Not mentioned were the two small outhouses about 200 feet from the building. The school housed 80 pupils for about 15 years, until demolished to erect a larger building.

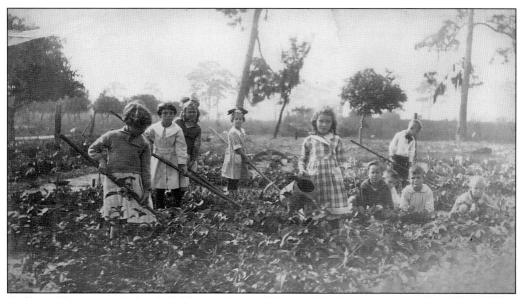

Gulfport Elementary School children cultivated Victory Gardens during the First World War. The girls' home economics classes used the garden produce to practice cooking.

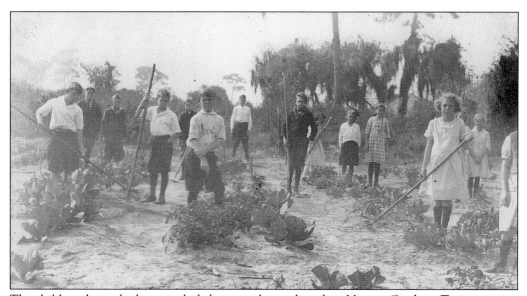

The children do not look particularly happy to be tending their Victory Gardens. Trying to grow cabbages in the sandy soil and hot sun must not have been an easy task. Boys who misbehaved were punished by being assigned to dig drainage ditches.

A "road" through Gulfport in 1915 was nothing more than a wagon-width clearing cut out of the native growth and grubbed down to the natural sand. This path leads beside a young orange grove, which many early residents planted to supplement their incomes.

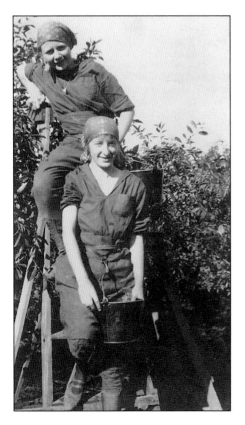

Two young girls pick citrus from a wooden ladder. Their uniforms of middy blouses and jodphurs suggest they might have belonged to a youth service organization.

Three

1920–1930

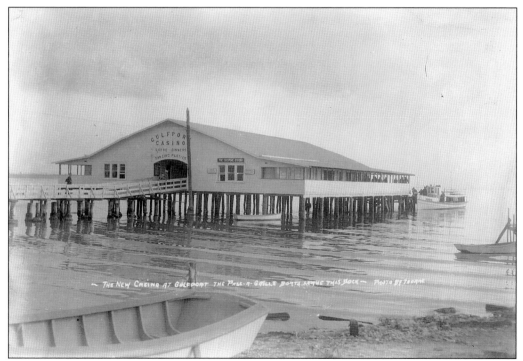

In October 1921, Gulfport suffered its worst natural disaster when a devastating hurricane struck the waterfront, destroying the first Casino, piers, fish houses, boats, and nets. This new Casino, built slightly inshore from its predecessor and mounted on flimsy pilings, was altogether a less satisfactory structure. It did still have a great dance floor and attracted crowds who often seemed to threaten the safety of the quavering building with their stomping.

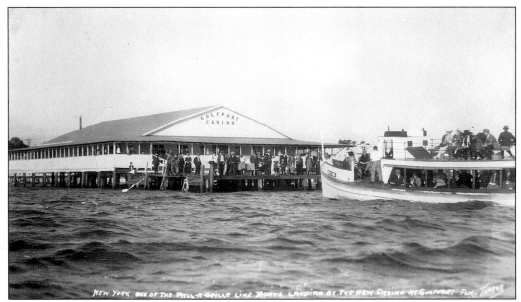

By the early 1920s, the trolley/boat method of transportation was giving way to automobile travel over new bridges to the beaches. Since the hurricane, the streetcar stopped at the water's edge, but people still walked out to the Casino to board excursion boats. The small passenger boat *New York*, shown loading here for a trip to Pass-a-Grille, carried about 50 people.

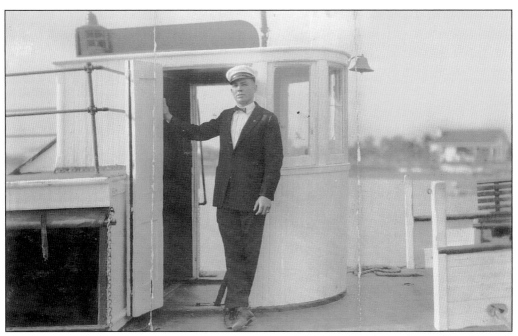

Young Leander White, pictured in his 20s, captained the *New York* on the Gulfport-Pass-a-Grille run. Private operators had taken over the mail and passenger route, now no longer owned by the streetcar line. Leander was a grandson of the Barnett family, the first settlers of Gulfport. (Courtesy of Nathan White.)

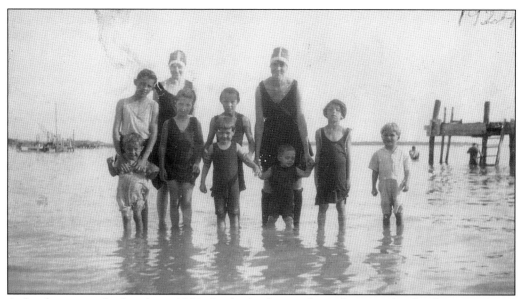

A family enjoys the beach in 1924. In the background can be seen the fondly remembered diving platform, which apparently endured many years of use despite its rickety appearance.

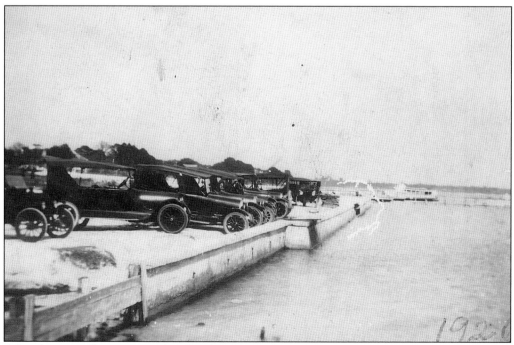

After the sea walls were completed and the tidal flats filled in with beach sand, cars could drive right to the water's edge.

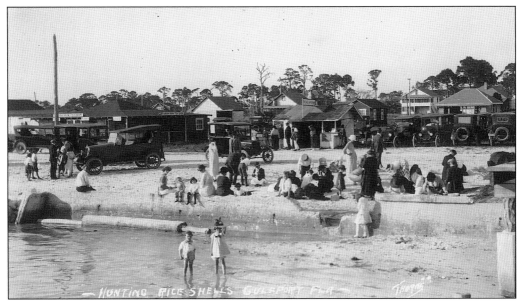

Gulfport beach was a lively place in the 1920s. The caption on this 1926 postcard, which shows the beach between the pier and the Casino, says, "Hunting Rice Shells," and may depict a special outing, as even the children are dressed in their Sunday best. Rice shells looked something like tiny grains of rice and could be strung together to make pretty little necklaces.

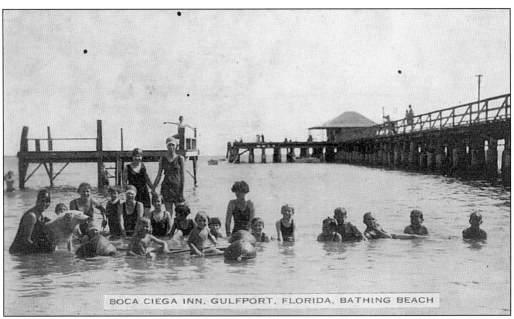

These swimmers frolic beside the first public pier, built in 1918–1919 to replace the original private pier of Mayor Wintersgill. Made of wood, it had a refreshment stand on the end and stood until 1936, when it became unsafe and had to be demolished.

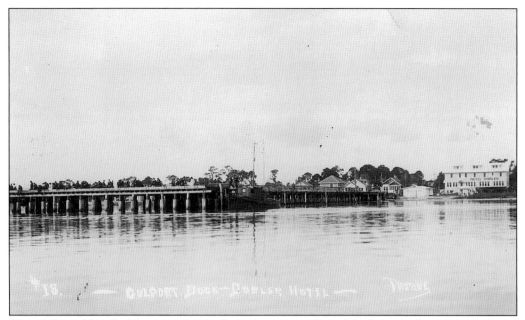

The 't'-shaped head of the pier, as seen from the water, allowed for boat docking. Just to the east stands the new Dobler Hotel, an imposing structure of stucco-covered wood frame built in 1922. It had 42 rooms and a dining room and was intended as a fishing lodge.

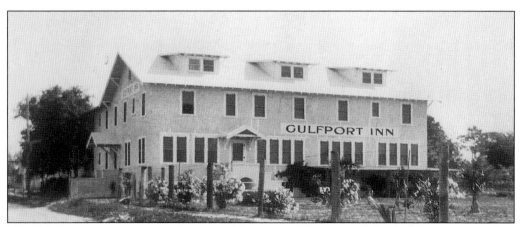

The Dobler was never an entirely successful venture. The owner, John Dobler, was reputed to be a poor manager, and the hotel was usually largely vacant. At some time during the decade, the hotel was also known as the Gulfport Inn.

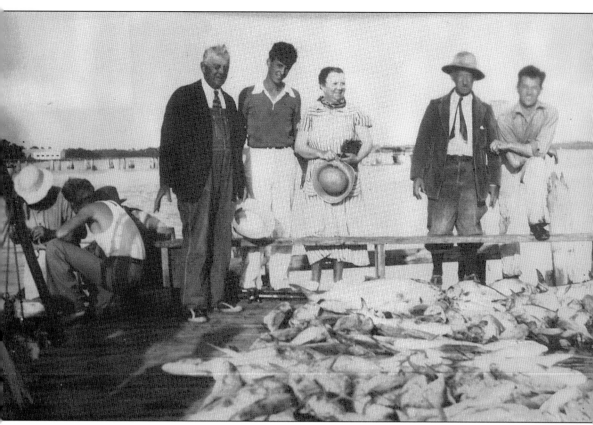

Local boat owners were now devoting most of their time to taking out fishing parties. Fish were so plentiful in the early days that visitors described them as "almost filling the bay." Daily at 5 p.m., commercial fishermen returned with 500–700 hundred pounds of grouper, amberjack, and mackerel, which they threw onto the pier and cleaned while tourists watched, as shown here.

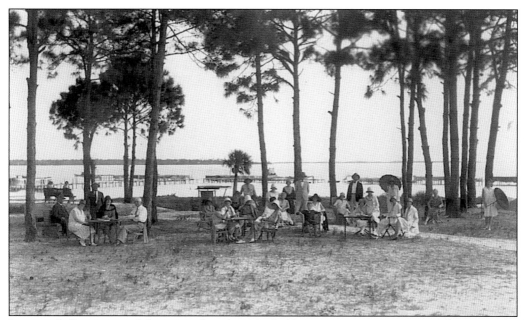

In a good illustration of the two sides of 1920s Gulfport, vacationers are seen relaxing at the waterside, while behind them commercial fishermen's nets are spread in the bay. The location is identified as being between Fifty-second and Fifty-third Streets. Net spreads allowed for cleaning, drying, and mending.

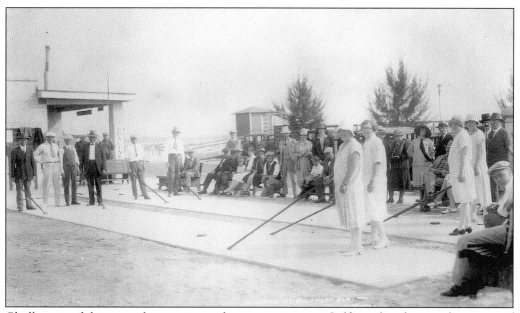

Challenging fishing as the most popular recreation on Gulfport beach was the game of shuffleboard. In this 1928 picture, a group of tourists in their best resort wear compete on the new courts.

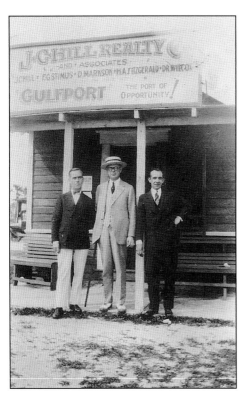

The little waiting station across from the Casino still served as a real estate office in 1927. Now owned by J.C. Hill and Associates, the company proclaims Gulfport "The Port of Opportunity" on its sign.

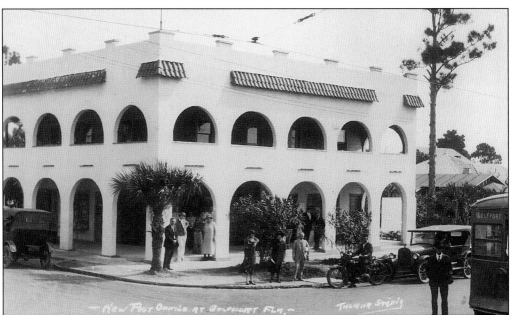

Two blocks north, at 3000 Beach Boulevard, a new commercial building in the Mediterranean Revival style was being built by Walter O. Brooks, who had arrived in the area c. 1913 and began serving as the town's postmaster in 1915. The post office was located in this building until the branch was abolished in 1928. At that time a variety of businesses occupied the ground floor, while the Brooks family lived upstairs.

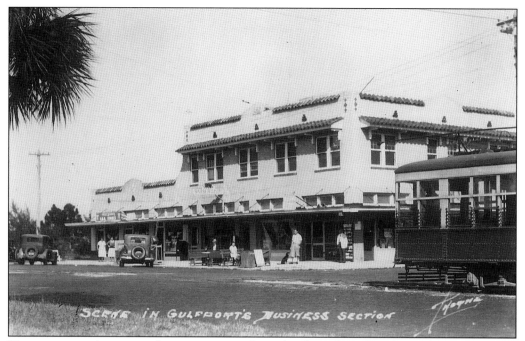

The commercial center of town continued to develop along Beach Boulevard with the construction of this building in the 2800 block. Tom Hucknall was the builder, and the original tenants were a pharmacy and a grocery store. Gulfport now had, as noted on the postcard, a "business section."

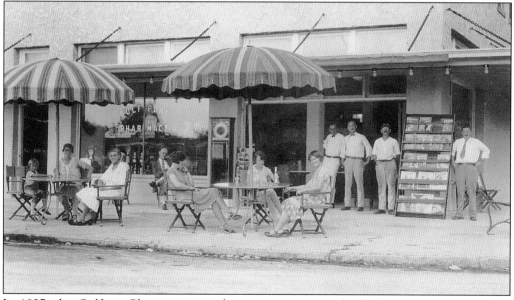

In 1927, the Gulfport Pharmacy treated its customers to umbrella-shaded outdoor tables, a pleasant setting for a drink from the soda fountain or a chat with other shoppers.

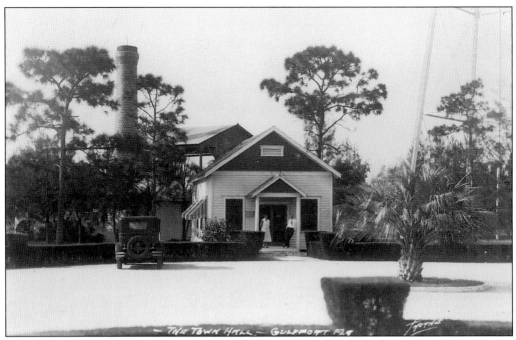

The town was feeling the effects of the great Florida land boom. The area population tripled between 1923 and 1928, and some 300 new buildings were constructed. City hall was moved to today's location at Fifty-third Street and Twenty-third Avenue, and an incinerator and water tower were built. The building remained in use until 1953, when it was auctioned off and carried away in pieces.

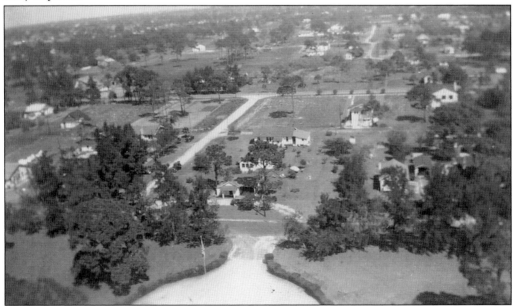

This view from the top of the old water tank beside city hall shows Twenty-third Avenue slanting upward toward Fifty-second Street. The circular driveway with the flagpole in the center was in front of city hall. Across the street, with the curved drive, there was a little store that sold candy and gas.

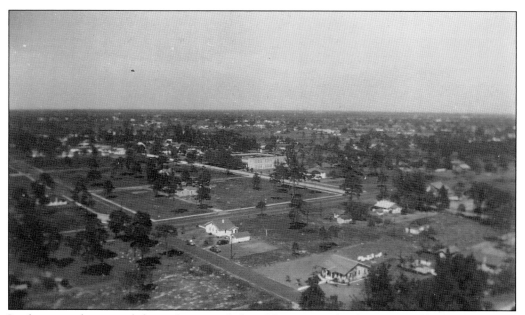

Looking northeastward from the top of the old water tank, the new Gulfport Elementary School can be seen in the center of the photo, along Fifty-second Street, which slants upward, to the left.

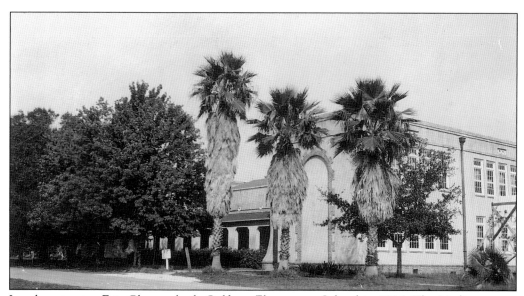

Local contractor Eric Clausen built Gulfport Elementary School in 1926. The Mediterranean style-building cost $95,000 to construct and featured 16 classrooms arranged around a central auditorium with a seating capacity of 500. A cafeteria was added in 1948 and a four-room wing in 1954.

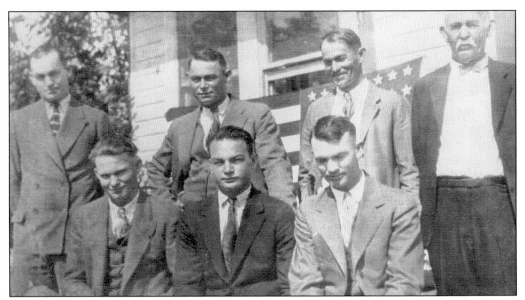

John Francis Girard (right) poses with his sons in 1927. From left to right are (seated) Jerome, Ted, and Steven; (standing) Jack, Otis, and Roland. The youngest, Jerome, who was 21 years old in this picture, worked for the City and was an early Gulfport scoutmaster. Leading Troop 15 throughout the 1930s and 1940s, Jerome Girard was a great influence on the lives of many boys of that era.

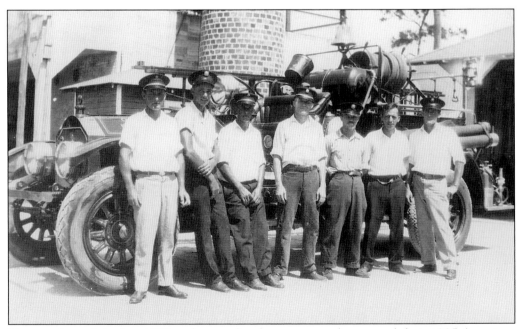

The members of the late-1920s volunteer fire department gather around their 1925 American LaFrance fire engine. From left to right are Assistant Chief Irving Slaughter, Russell Barrow, Chief Sidney Webb, Wesley Webb, Frank Anthony, Ralph McRoberts, and Norman Huckins. Sidney Webb was Gulfport's first official fire chief, serving until 1934.

In 1924, Alvah Roebuck retired from the company he had started with R.W. Sears and came to Gulfport to build one of Sears's "Kit Homes." He soon bought a tract of land in the southeast part of town and built more of these small, attractive houses in an area that came to be known as Roebuck Park. This structure is on Delett Avenue.

The bungalow was another popular residential architectural style during the 1920s building boom. This house on Twenty-seventh Avenue was built by Charles Hayes and was originally located on Fifty-second Street.

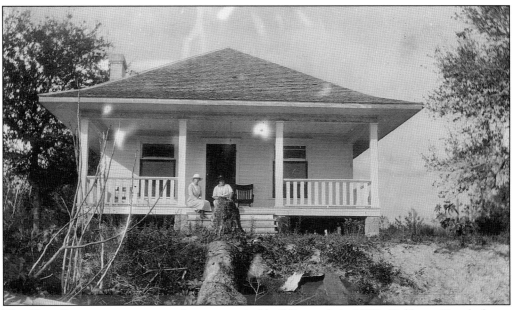

The Chandler cottage represents the most typical building style in 1920s Gulfport. Simple frame cottages sprang up throughout the waterfront area to accommodate the burgeoning numbers of winter visitors and permanent residents.

Mrs. Louise Chandler sent this card to her mother with wishes for a happy New Year in December 1923.

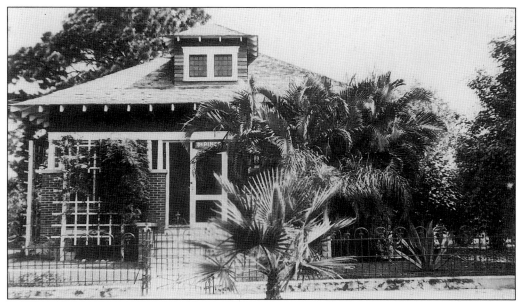

"The Pines" on Delett Avenue, shown here in 1926, is architecturally similar to the Chandler cottage, although much larger.

Another Delett Avenue home, known as the Morrison house after its builder, is in the frame vernacular style. The building has had few alterations and retains most of the architectural integrity of its 1924 construction.

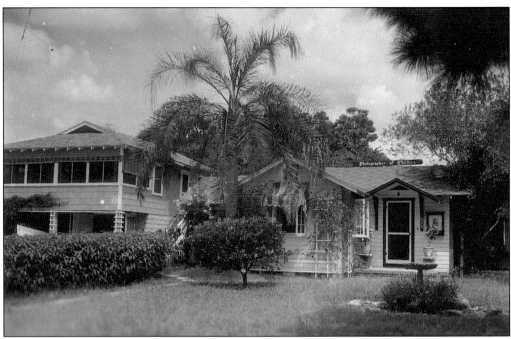

One of the town's most prominent residents was photographer Harry Thorne, whose home and studio, shown here, were built on Thirty-first Avenue c. 1925. Mr. Thorne, who was the official spring training photographer for the Yankees and Braves, took many of the pictures in this book. He also had a studio for a time in the front of the second Casino.

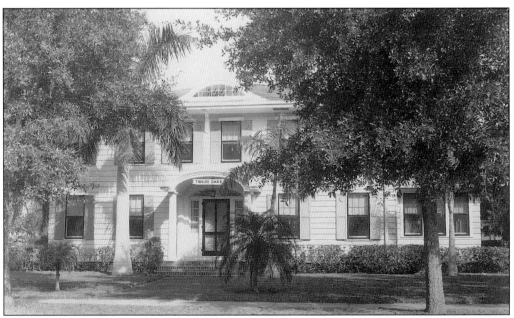

The Yates House on Twenty-seventh Avenue is now called "Twelve Oaks" and is used as an apartment building. It was built c. 1928 in the Colonial Revival style. Mrs. Yates was a realtor in partnership with Sam Webb, a member of one of Gulfport's founding families and the first town clerk.

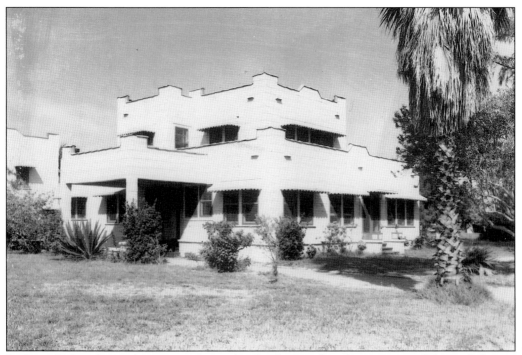

Built c. 1925 in the Mediterranean Revival style, the Burnham house was on Fifty-sixth Street, just north of the waterfront. The building's owners called it the "Fortress-by-the-Bay" and cultivated a cactus plant (shown at the left), then thought to be over 100 years old.

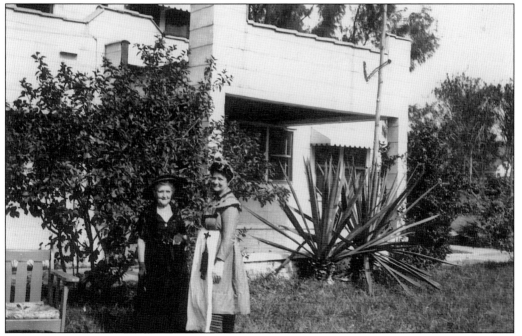

The cactus stems were used to make pincushions which kept needles from rusting in the humid climate. The ladies here are dressed for a "recitation" in vintage clothing and hats, which, they noted, were "from Paris."

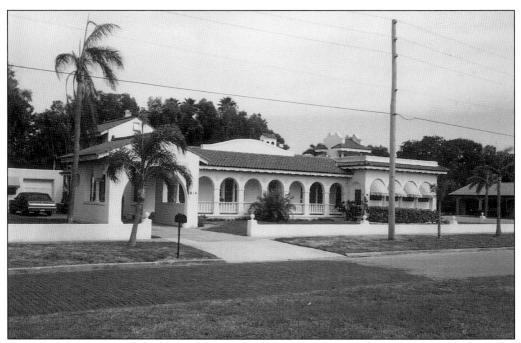

This home on Sixty-first Street is significant for its association with the development of the Pasadena Estates section of Gulfport by Jack Taylor, who also erected the Rolyat Hotel, now Stetson Law School. Built in 1924, it too is in the boom time's favorite Mediterranean Revival style.

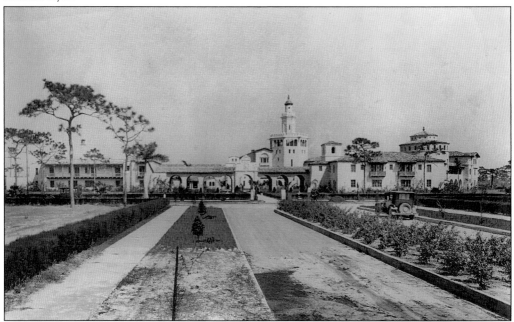

The Rolyat (Taylor spelled backwards) Hotel was designed in 1925 to emulate a Spanish feudal castle. The 110-foot, octagonal main tower is a replica of the Torre del Oro of Seville. As the Florida boom times came to an end in 1928, the hotel failed and was sold to pay construction costs.

Jack Taylor spared no expense to create an authentic atmosphere for the guests of his Rolyat Hotel. These young ladies are the "Spanish Table Girls" who served as waitresses in the dining room, which was vaulted to resemble the nave of a medieval cathedral. Guests dined on 13-piece place settings of Lamberton China and Reed-Barton silver purchased from Wanamaker in New York.

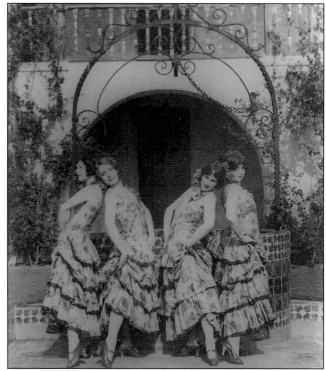

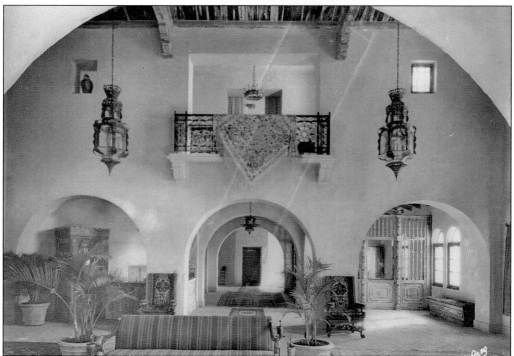

The Rolyat's lobby was patterned after a monastery chapel, with prayer recesses, a balcony, and authentically medieval floor tiles. Through the arches can be seen one modern concession: the elevator to the golden tower.

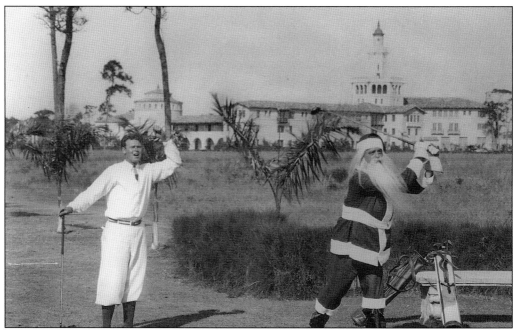

The golf course was nearly in the front yard of the Rolyat Hotel. Golf greats Bobby Jones and Gene Sarazen were among the well-known golfers who played this course soon after it was laid out in the early 1920s by Walter Hagen. The 18-hole championship course was proclaimed the finest in the South, as well as one of the most beautiful in the entire country.

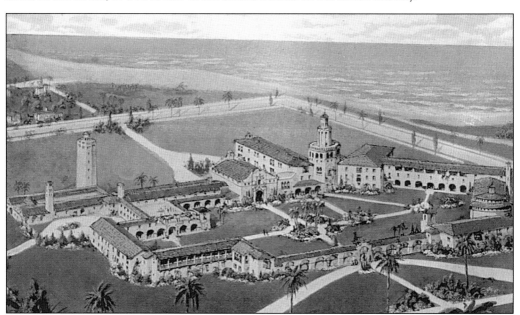

Advertising the Rolyat for its "accessibility to the fine Gulf beaches, broad, sloping, and snowy white" may have necessitated the doctoring of this promotional photograph to include the waters of the bay, which were, in fact, far beyond an extensive area of mud flats and bayous. The advertisement didn't help; the boom had gone bust, and the Rolyat suffered financial collapse. Gulfport had entered the Depression.

Four

1930–1940

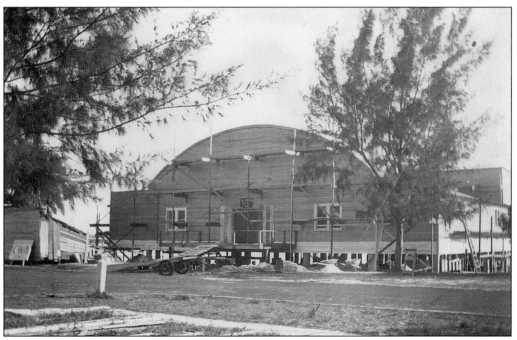

The second Casino, never a sturdy construction, had succumbed to building code violations and been torn down. Now, with the local economy beginning to show signs of recovery, Gulfport turned to a New Deal agency to help with the building of a third Casino. The town's Civil Works Administration pooled resources with the Federal Emergency Relief Administration in the mid-1930s, and a new Casino was soon going up.

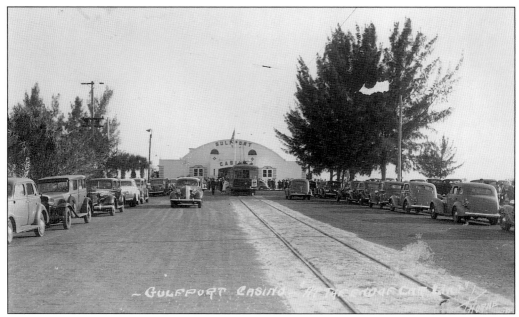

Moved inshore yet a bit more, the third Casino now sits directly on Shore Boulevard. Trolleys still brought passengers right to the door, but as can be seen here, automobiles were becoming an equally important means of transportation to Gulfport's waterfront. The curved parapet has often been compared to the military Quonset hut, but that style originated at the Quonset, Rhode Island Naval Base in 1941, six years after the construction of the Casino.

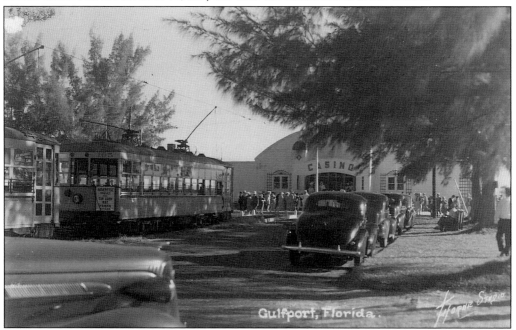

Dancers arrive in the late afternoon for one of the Casino's many events. A new dance floor, even finer than before, was called the best in Florida if not the entire South. Made of solid maple and never waxed, the floor was treated with commercial paraffin and yellow cornmeal to create a perfect surface on which dancers could glide but not slip.

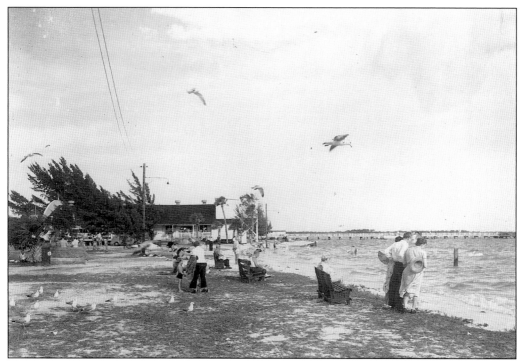

A side view of the Casino taken soon after its dedication in December 1935 shows how it looked from the beach to the west before its porches were enclosed.

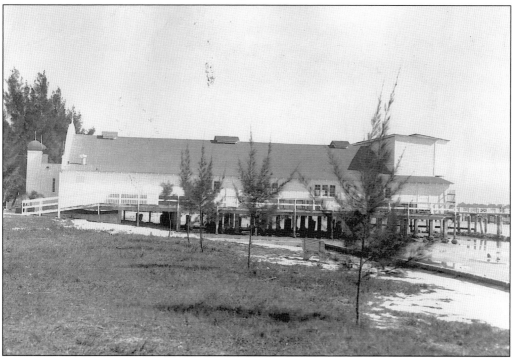

This shows the Casino, now completed, from the same angle. In later years, the beach beneath it would be filled in and a sea wall built. The city's entire cost of the 1935 project was $16,000.

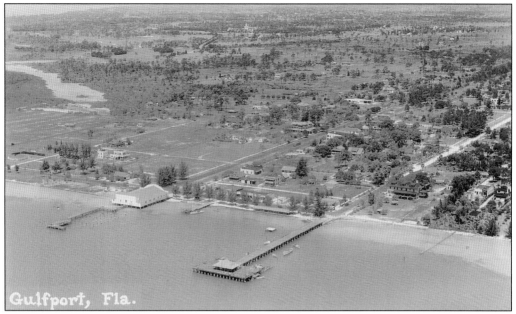

Gulfport, Fla.

This aerial view can only date from 1936, after the construction of the third Casino and before the demolition of the old wooden pier later that same year. A new pier of steel and concrete would soon be built, also with federal aid, 500 feet into the bay. The "tinker dock" between the Casino and pier was used by commercial net fishermen.

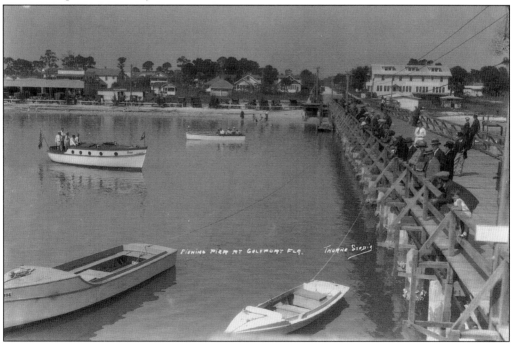

In another look at the old wooden fishing pier, the Boca Ciega Inn, formerly the Hotel Dobler, can be seen at the upper right. Many of the gentlemen who fished from the pier were hotel guests who could, if they wished, order lunch and have it brought to them by the hotel staff so they would not have to lose their positions. (Courtesy of Nathan White.)

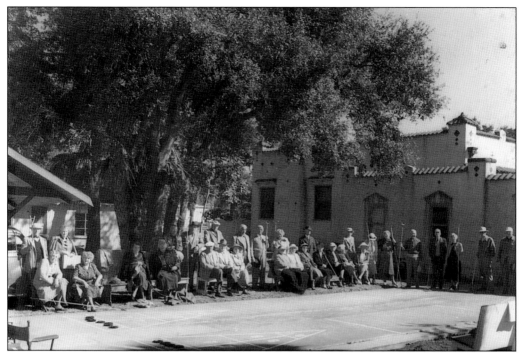

Life at the Boca Ciega Inn was now in full swing. Mr. and Mrs. Paul Camp had acquired the old Dobler Hotel in 1932 and made it into a fine resort catering to wealthy visitors from all over the country. Famed for its good food and many activities, it was always full and something was always happening, from shuffleboard tournaments to black-tie Thursday evenings to jam-packed Sunday dinners.

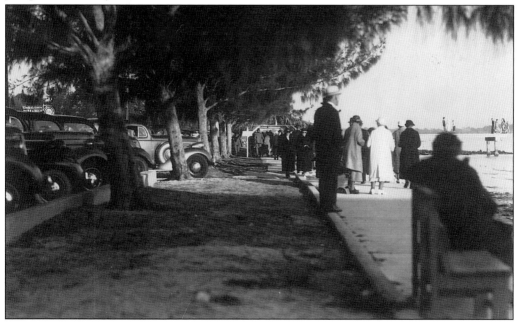

Even on an obviously cold day in the 1930s, people crowded the waterfront on their way to one of the many events.

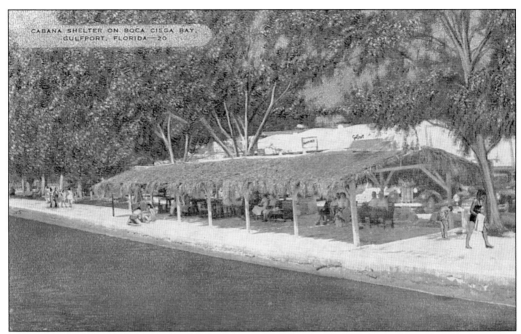

CABANA SHELTER ON BOCA CIEGA BAY, GULFPORT, FLORIDA—20

A thatched-roof cabana brought a "native atmosphere" to Boca Ciega Bay, according to this postcard. "Visitors spend many hours enjoying watching the bathers and fishermen and seeing the dolphin and porpoise swim about close to the shores."

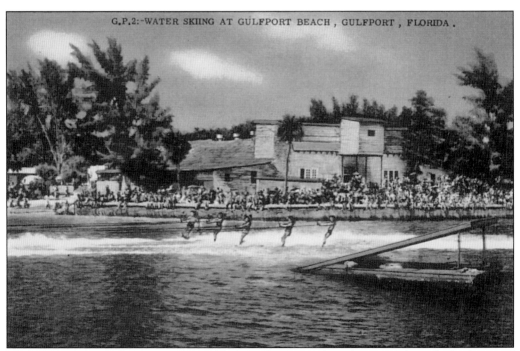

G.P.2:-WATER SKIING AT GULFPORT BEACH, GULFPORT, FLORIDA.

The Casino appears almost unrecognizable from this unusual southwest angle in the background of this postcard showing a water-skiing exhibition.

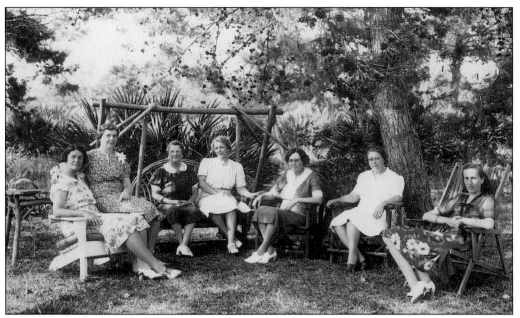

Gulfport was developing a new class of ladies, the clubwomen, led by people like the Camps and the Thornes. Here, Mrs. Thorne, at the left, entertains at an unidentified gathering.

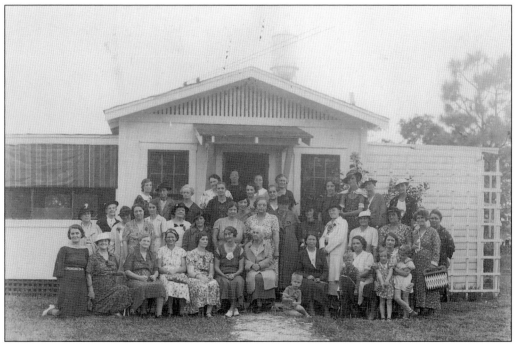

The Home Demonstration Club was one of those newly formed organizations. Here, the group meets in front of a Lakeview Avenue (now Gulfport Boulevard) home in November 1936.

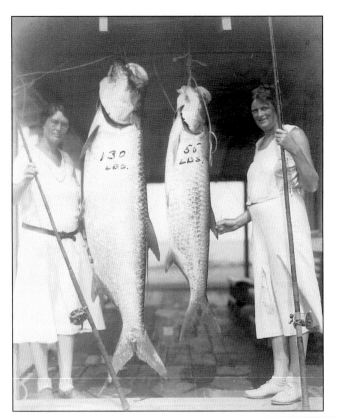

Harry Thorne's wife, Kathryn, and neighbor Marie Wilson show off good-sized tarpon caught by the photographer. Tarpon was the tourists' favorite fish.

Eddie Markham shows off his prize shark in 1937. His dad, Edwin A. Markham, came to Gulfport in 1934 and opened a real estate office with R.W. Caldwell. Markham and Caldwell separated in 1937, though both remained in the real estate business, and both were active in city government and civic affairs.

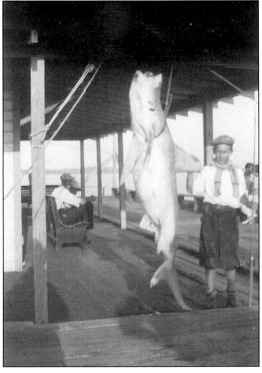

Local men fished for both fun and profit. From left to right, Jack Fuller, Jay Auble, and Earl LaSalle pose outside the Markham Real Estate office to show off their catch of silver king (tarpon).

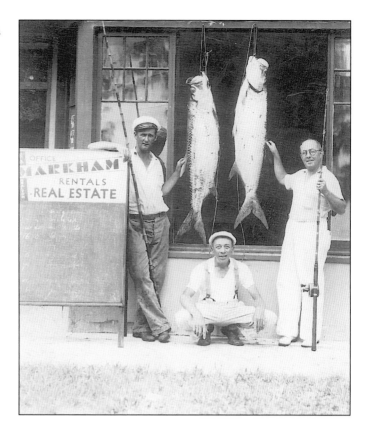

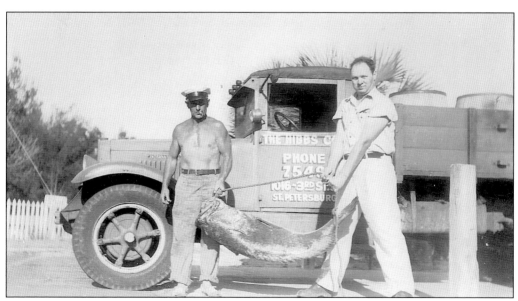

John "Frenchy" LaJoie (left) and a Hibbs Company worker load a large jewfish onto the company's truck at Gulfport pier. Fishermen favored dealing with the Hibbs Company due to their policy of advancing credit for food, nets, and other necessities during lean times

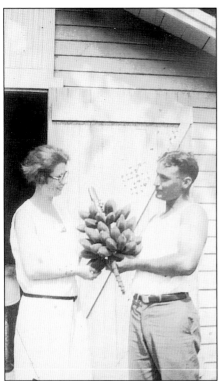

Among the active young people of this era were Gladys and Norman Huckins, shown here with a good bunch of bananas. Norman served on the town's volunteer fire department for 50 years. Bananas were grown successfully in Gulfport, particularly by former mayor Nathan McKinney at his Fifty-sixth Street home, where he ran a shipping business called Banana and Glad Gardens.

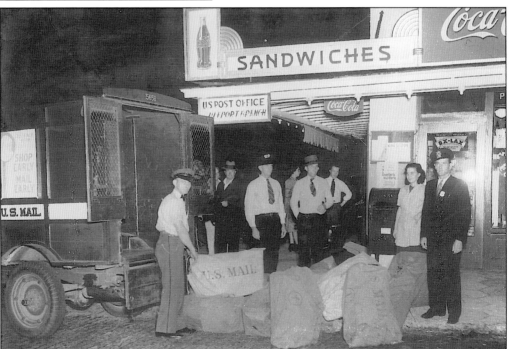

Norman Huckins is seen again in this picture of a mail delivery or pick-up outside the Gulfport Pharmacy. Norm is standing to the left of Police Chief Lloyd Holland; both men are wearing white shirts and ties.

Another member of Gulfport's younger group was Betty Jane Montigney, shown here at the end of the decade. She later married Mert Barrs, a contractor who was instrumental in the construction of the new Methodist church.

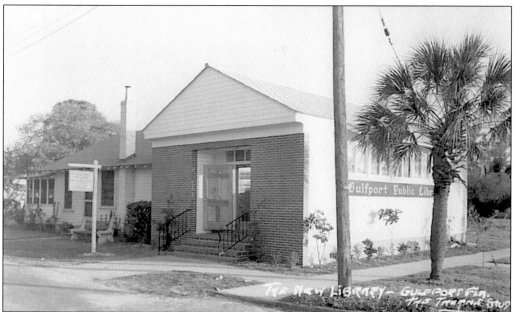

In 1935, a group of citizens founded the first public library, shelving and cataloging 1,500 donated books in an abandoned one-room office. Mrs. Thorne and Miss Montigney were among those who volunteered to serve the 300 patrons. Soon a new building was donated and the Gulfport Public Library opened on the corner of Delett and Beach Boulevard, as shown here.

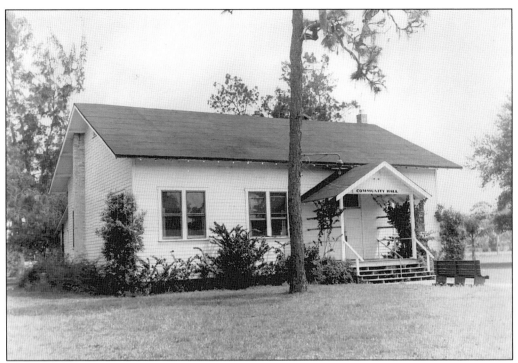

Community Hall, constructed *c*. 1920 as a Pentecostal church, was originally located in the 2600 block of Forty-ninth Street. The structure was acquired by the City and moved to its present location in Chase Park in the late 1930s for use as a community center and meeting site for all of the town's clubs. The building now houses the local chapters of the Boy and Girl Scouts.

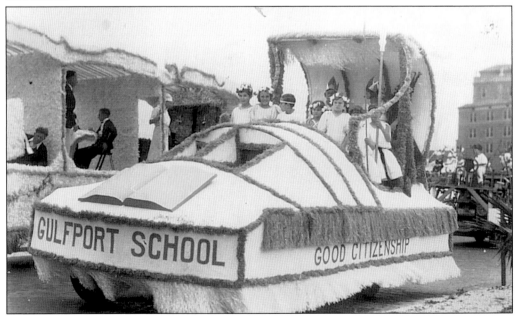

Gulfport Elementary School sent a float to St. Petersburg's Festival of States in 1936. Thorne and Montigney children are among those aboard.

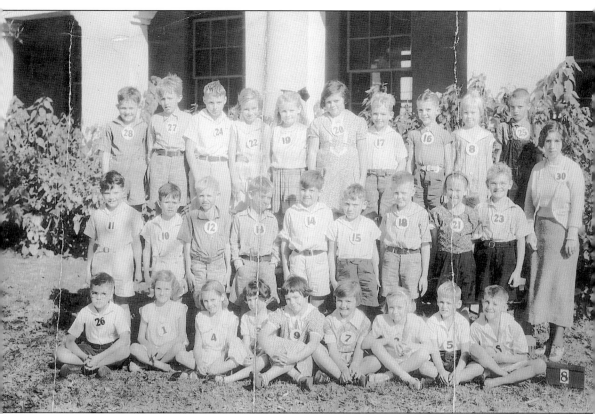

In 1929, Gulfport Elementary had come under the leadership of Mrs. Mary Lou Gray, who served as principal for the next quarter of a century. Gray stressed the school as the center of the community, with pageants and functions and special holiday observances. Here, in Cora Moore's third-grade class in 1935 are many familiar names, including Whitworth, Huckins, Holland, McRoberts, Brooks, and Girard.

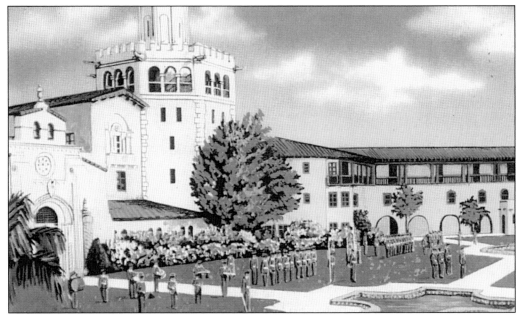

Another school came to town when, in 1932, the defunct Rolyat Hotel was purchased by the Florida Military Academy. The academy, founded in 1908, was a Reserve Officers Training Corps military preparatory school for grades one through twelve.

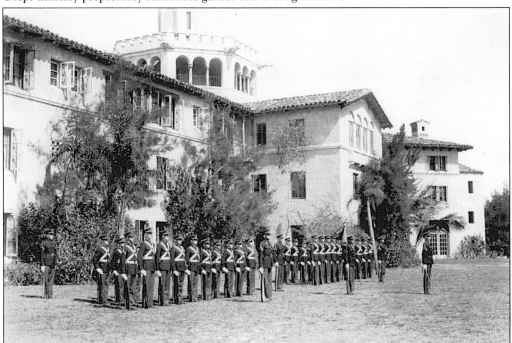

Strict military discipline prevailed at the academy, where weeks of serious academic and athletic pursuits were followed on Sundays by a parade on the school grounds with staff and color guard. The school closed in 1952, after the death of its major stockholder. Many graduates achieved local and national prominence, not only in the military but also in business, government, and the professions.

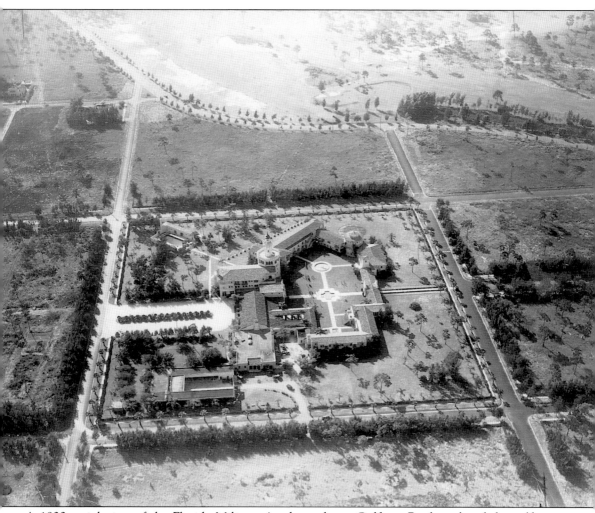

A 1933 aerial view of the Florida Military Academy shows Gulfport Boulevard and the golf course at the top of the picture. The undeveloped land around the school allowed plenty of area for staging simulated battles.

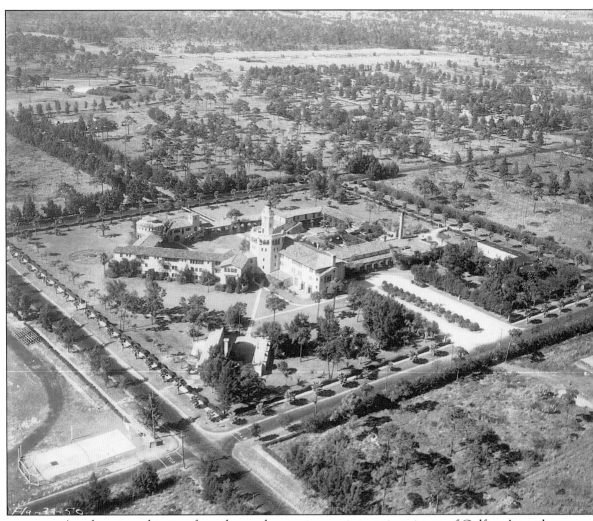

Another view, this time from the southeast, gives an interesting picture of Gulfport's northeast section in the 1930s. No further residential building had been attempted since the boom times of the mid-1920s, and the neighborhood stands vacant except for one Mediterranean Revival house on about every block.

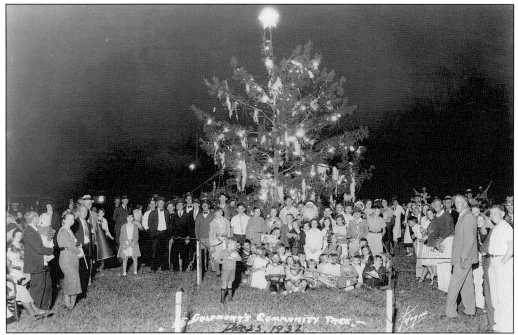

Mayor Clifford Hadley started the tradition of having a community Christmas tree in 1932, a custom which is carried on to the present day. This picture was made into a card commemorating the event, and the card was sent by the mayor to "all who helped make this possible."

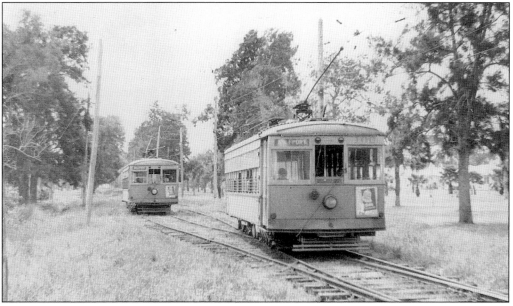

Today's holiday tree is located in Clymer Park at this location, where in the 1930s this bypass in the trolley track allowed for streetcars to pass each other. Schedules were not always precise, and there were often long waits for a car that never came. Still, that was better than meeting another trolley head on, which happened all too often and involved the difficult and time-consuming process of backing up.

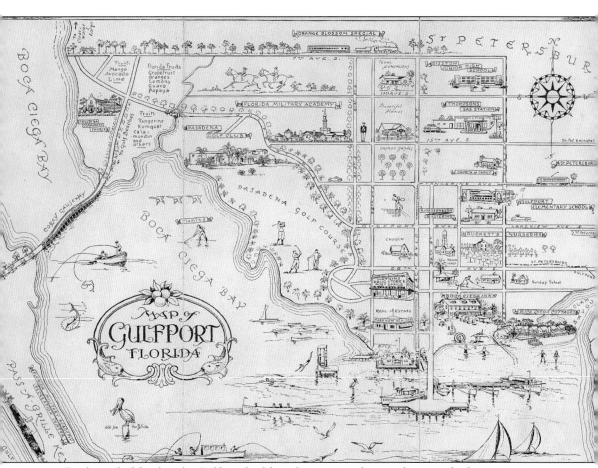

By the end of the decade, Gulfport had found a secure niche as a charming little resort community of cottages and homes, with a lively waterfront offering swimming, boating, fishing, and fun, as shown in this delightful 1938 promotional map. International problems were a distant concern for these people whose lives centered on work and play, church and clubs. But the boys who built their little skiffs and sailed in the waters of Boca Ciega Bay would all too soon be sailing very different and dangerous seas.

Five

1940–1950

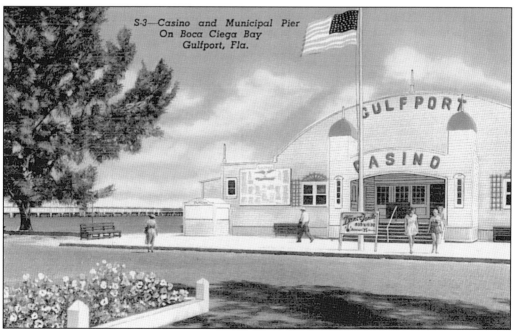

In the 1940s, probably more than ever before, the Casino was the center of the community. It continued to be the site of dancing, boxing, church services, card parties, political speeches, concerts, and school functions. The Casino had seen the beginning of many friendships, but now it bore the sad toll of lives disrupted by the war, as a list of those in service appeared on the Honor Roll to the left of the door.

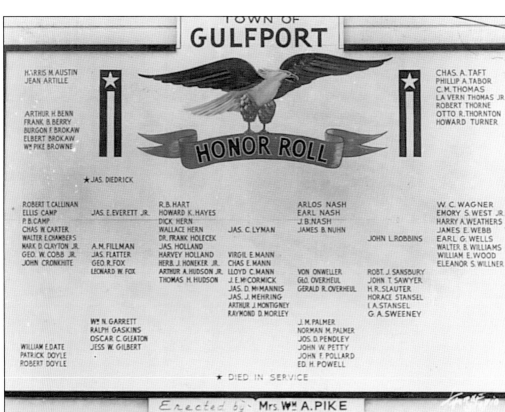

TOWN OF GULFPORT

HONOR ROLL

HARRIS M.AUSTIN
JEAN ARTILLE

ARTHUR H.BENN
FRANK B.BERRY
BURGON F.BROKAW
ELBERT BROKAW
Wᴹ PIKE BROWNE

CHAS. A.TAFT
PHILLIP A.TABOR
C.M.THOMAS
LA VERN THOMAS JR.
ROBERT THORNE
OTTO R.THORNTON
HOWARD TURNER

★ JAS. DIEDRICK

ROBERT T.CALLINAN		R.B.HART		ARLOS NASH	W. C. WAGNER
ELLIS CAMP	JAS. E.EVERETT JR.	HOWARD K.HAYES		EARL NASH	EMORY S.WEST JR.
P.B.CAMP		DICK HERN		J.B.NASH	HARRY A.WEATHERS
CHAS. W.CARTER		WALLACE HERN	JAS. C.LYMAN	JAMES B. NUHN	JAMES E. WEBB
WALTER E.CHAMBERS		DR. FRANK HOLECEK			EARL G. WELLS
MARK D.CLAYTON JR.	A.M.FILLMAN	JAS. HOLLAND		JOHN L.ROBBINS	WALTER B. WILLIAMS
GEO. W.COBB JR.	JAS. FLATTER	HARVEY HOLLAND	VIRGIL E.MANN		WILLIAM E.WOOD
JOHN CRONKHITE	GEO. R.FOX	HERB. J.HONEKER JR.	CHAS E.MANN		ELEANOR S.WILLNER
	LEONARD W. FOX	ARTHUR A.HUDSON JR.	LLOYD C.MANN	VON ONWELLER	ROBT. J.SANSBURY
		THOMAS H.HUDSON	J. E.McCORMICK	GEO. OVERHEUL	JOHN T. SAWYER
			JAS. D.McMANNIS	GERALD R.OVERHEUL	H. R.SLAUTER
			JAS. J. MEHRING		HORACE STANSEL
			ARTHUR J.MONTIGNEY		I. A.STANSEL
			RAYMOND D. MORLEY		G. A. SWEENEY
	Wᴹ N. GARRETT			J. M.PALMER	
	RALPH GASKINS			NORMAN M.PALMER	
	OSCAR C.GLEATON			JOS. D.PENDLEY	
WILLIAM E.DATE	JESS W. GILBERT			JOHN W. PETTY	
PATRICK DOYLE				JOHN F. POLLARD	
ROBERT DOYLE				ED. H. POWELL	

★ DIED IN SERVICE

Erected by Mrs. Wᴹ A.PIKE
IN MEMORY OF HER HUSBAND

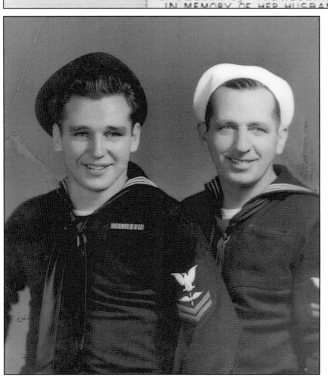

The WW II Honor Roll was a fixture on the facade of the Casino until the building's reconstruction in 1950. This photo shows some 80 names, and as many were to be added again before the war's end. Most of the town's young men, including the entire membership of the Gulfport Yacht Club, served.

Ralph McRoberts (right) and his son Ralph Jr. served together in the U.S. Navy in WW II. Ralph Sr. operated the Snow White Laundry on Lakeview Avenue and was a streetcar conductor on the Gulfport run for many years. Both men came home safely after their tours of duty.

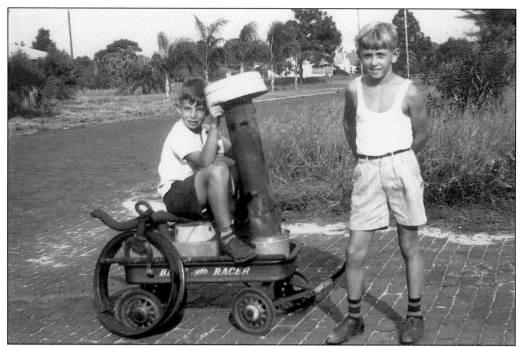

On the home front, kids were busy doing their part by collecting scrap metal for the war effort. Here, hard at work, are Mark Girard (riding) and Bill Renney (pulling the wagon). Bill's father, Sam Renney, disappeared while fishing at sea in 1943, a mysterious occurrence thought to be in some way connected with enemy submarines spotted in the Gulf of Mexico.

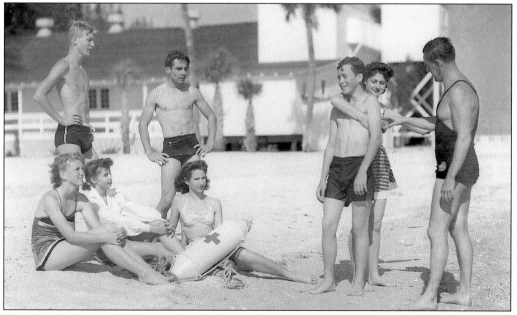

The teenagers organized themselves into a beach patrol and life saving corps. Members of the class practicing for certification are, from left to right, as follows: (seated) Anna White, Glennis Schultz, and Anna Marie Gaskins; (standing) Allen Miller, Don Fitzpatrick, James Stambaugh, Julia Jean Gray, and Red Cross instructor Bob Zubrod.

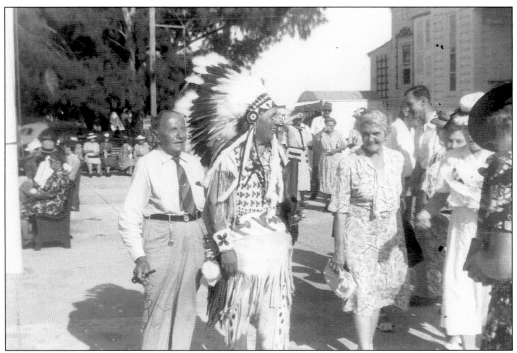

Meanwhile, at the Casino, spirits were kept up by a visitor called Chief Silver Tongue, who led community sings every Sunday afternoon during the winter. Celebrities were occasionally spotted in Gulfport during this period; two notables were famous figure skater Sonia Henie and author Stuart Cloete, who both vacationed here in the early 1940s.

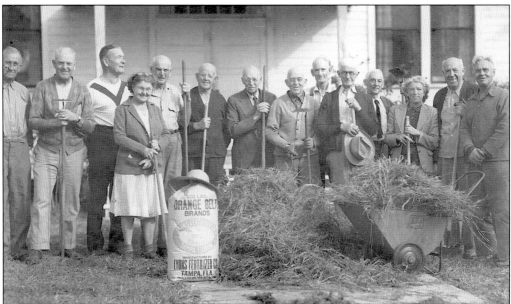

And there was still plenty of work to do. Here, Garden and Bird Club members stand ready to dig sandspurs around Community Hall in November 1943. From left to right are Mr. Atwood, Mr. Weast, Mr. Sinclair, Mrs. Fisher, Mr. Brokaw, Mr. Crompton, Mr. Creamer, Mr. Jerome, Mr. Whitbeck, Mr. King, Mr. Meyn, Mrs. Creamer, Mr. Parker, and Mr. Franklin.

The war years saw the passing of many of the older members of original settlers' families. Margaret Aurelia Slaughter Roberts, a granddaughter of Rebecca Barnett and wife of Walter Minton Roberts, who was also a descendant of several early Pinellas residents, was one of these. (Courtesy of Worthington family.)

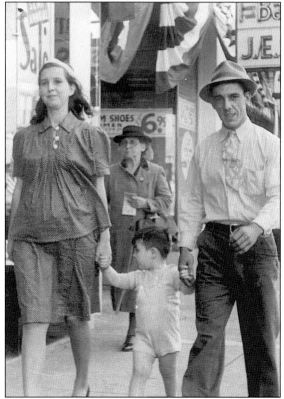

Margaret Roberts's daughter Iona and her husband, Harley L. Worthington, are shown taking their son Jimmy, age two, on a shopping excursion in 1941. (Courtesy of Worthington family.)

A new church appeared in town in 1944, when the Calvary Baptist Church was built at Fifty-fifth Street and Gulfport Boulevard. Once called the "Little White Church of the Singing Pines," it was surrounded by tall pines in which loudspeakers were placed so that chimes could be played to call people to worship. The total cost of the original building, which was expanded somewhat in the 1950s, was $3,700.

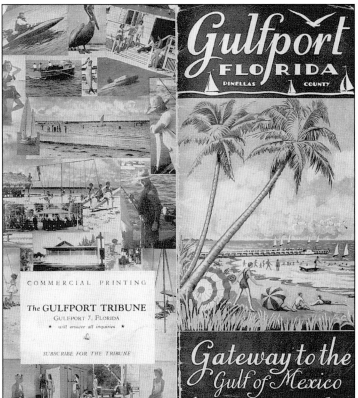

Gulfport had acquired a newspaper, too. The *Gulfport Tribune* referred to itself in this promotional brochure as "a progressive weekly newspaper that is published every Friday." The back cover of the brochure offers glimpses of the town and its activities, while the front cover shows an idealized drawing of the beach and pier at the "Gateway to the Gulf of Mexico."

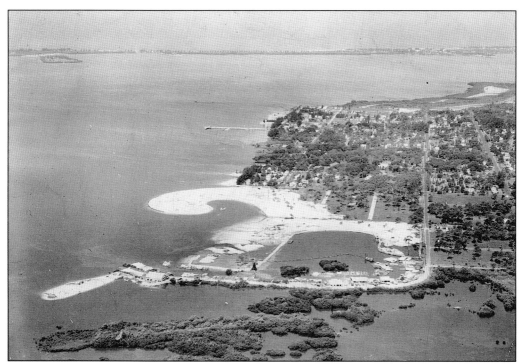

When the war ended, the town was ready to move forward again. In the summer of 1946, land was dredged out of the bayou to create new building space and cut a clear channel into the new marina. The spit of land in the foreground had come to be known as Osgood Point, after the Osgood family, who had located their boat-building business there in 1939.

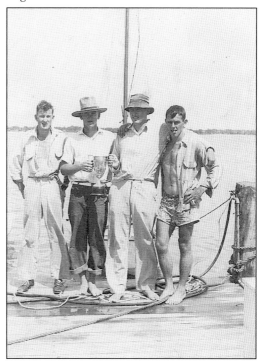

And then the boys were back. Here, with a prize cup awarded for success in a sailing regatta held just after the war, are, from left to right, Bruce Ellis, Nathan White, Jim McMannis, and John Thompson.

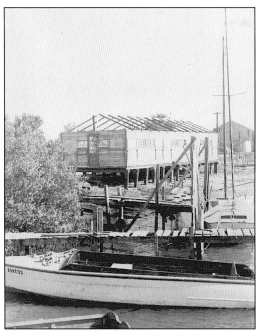

Building a clubhouse was the first post-war project for the Yacht Club members upon their return from service. The building came in pre-fabricated sections and was raised up on trolley ties salvaged from the demolition of the streetcar line.

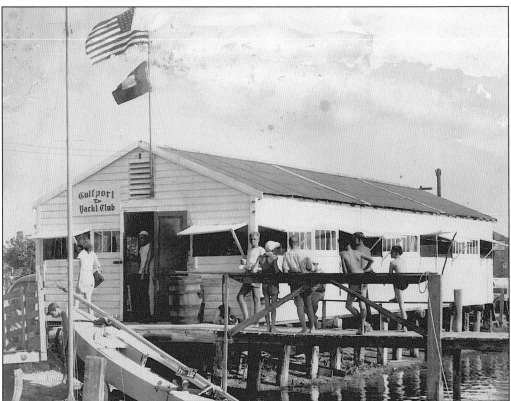

Once completed, the clubhouse became the headquarters for a new generation of Gulfport's young people, probably the last to grow up on the water, as their fathers and grandfathers had before them.

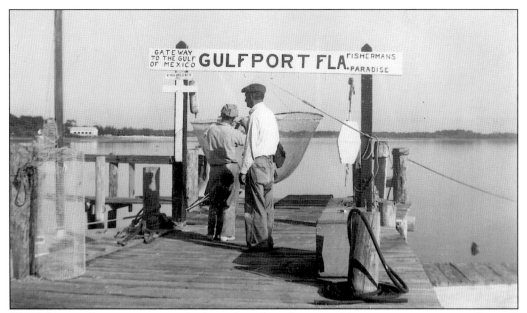

The fishing industry was seeing the last of its glory days, too. Here men prepare a net that will be used to catch bait for the next day's fishing. Paper bags full of minnows were lowered to the bottom on a weighted sounding line, then burst to chum fish. On shore (to the left) can be seen Clifford Hadley's boat building establishment, where he was acquiring renown for his world-class hydroplanes.

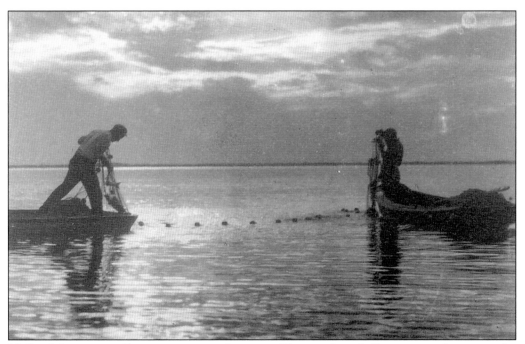

Mullet fishing was still a prime source of income. Three or four skiffs were towed out into the bay by power launch, then released and propelled by poling oar until a strike of mullet was made and the nets were lowered. Here, men gather the nets at the end of the day.

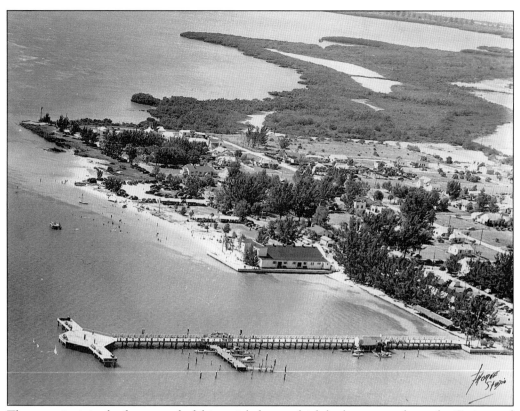

The new pier is in the foreground of this aerial photo, which looks westward past the Casino and beach toward marshland that would become the site of the Town Shores condominiums and the Pasadena Yacht and Country Club. No longer were any boats in sight between the Casino and the Pier, though for some years to come there would still be a bait shack and docking for boats on the east side of the pier.

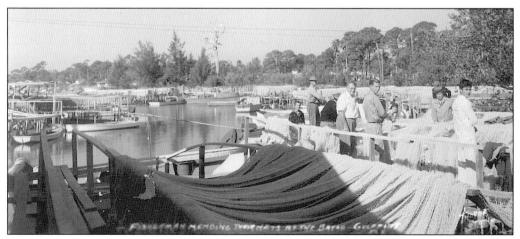

Net spreads had been moved to the Clam Bayou/Osgood Point area at the request of citizens who thought the sight and smell of them was not appropriate for the now tourist-oriented waterfront. Once dry, the nets were carefully mended (as shown here) since even a moderate-sized net might cost $400, a huge sum in 1940s Gulfport.

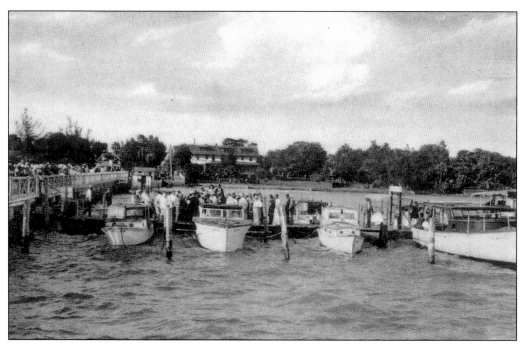

The east dock off the pier would be home to the commercial fishing fleet for a while longer. When it became an interference with the growing tourist trade, it too was relocated eastward to the Clam Bayou area. The Boca Ciega Inn can be seen in the background.

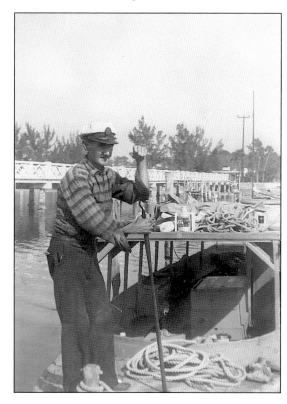

Seen at one of these berths is Captain Harry Yawger, who had run the *Joe* for decades, bringing mail and news and passengers to early island pioneers. Now he and other old-time boatmen began offering party cruises to visit beaches and keys and observe marine and bird life in the bay.

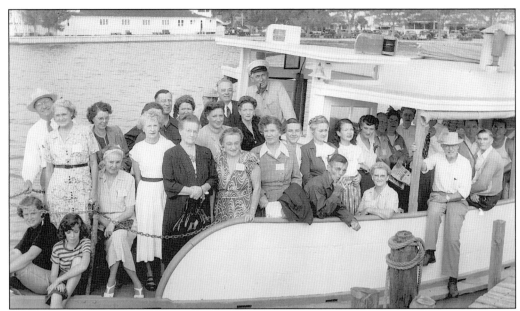

Certainly one of the best known of these party boats was Captain Walter Williams's *Don*. In this 1947 outing, Captain Williams, who was also the mayor of Gulfport, is at the center back, with a pipe and white cap. The passengers were local municipal officials, including developer Walter Fuller (center front with cigarette) and seated next to him is Mrs. Ethel McKinney White.

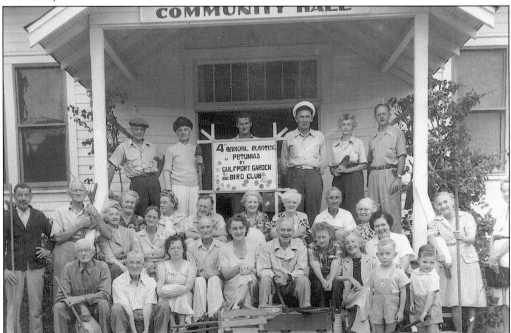

Mayor Williams, shown here again (center back with white cap), supervises the Fourth Annual Petunia Planting of the Garden and Bird Club. This 1946 picture demonstrates Gulfport's true community spirit as citizens of all ages set off to beautify the town with 1,000 new petunia plants.

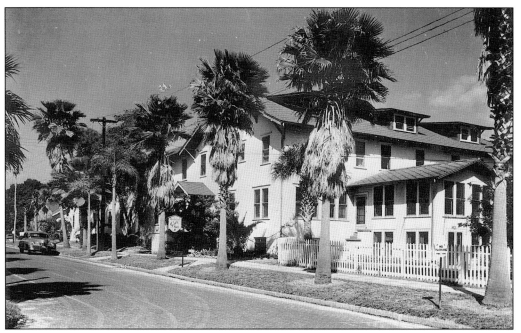

The Boca Ciega Inn continued to attract tourists to the town, although business was never quite as good in the post-war years. Mrs. Camp opened the Witchcraft Gift Shop in the hotel, and it became a popular place to buy handicrafts and other boutique items. This view of the hotel and shop looks north along Fifty-fourth Street.

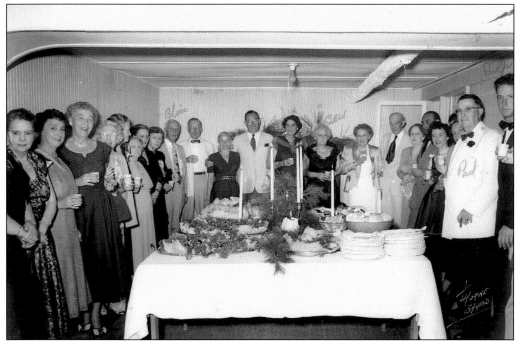

Guests enjoy one of the Boca Ciega Inn's famous gourmet buffets. Paul Camp Jr., who would take over operation in the early 1950s, stands at the far right, next to his father, Paul Camp Sr. Mrs. Bessie Camp is the white-haired lady at the center back in the dark, scoop-necked dress.

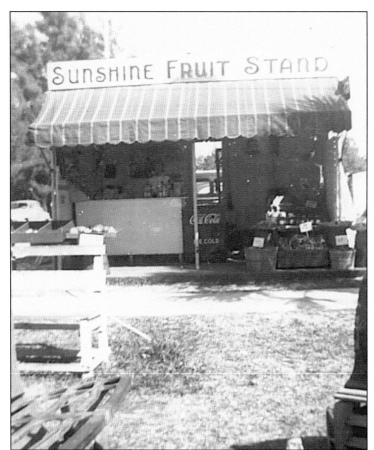

The Sunshine Fruit Stand, owned by Phoebe Arms, stood at the corner of Beach Boulevard and Essex Avenue. Mrs. Arms came to Gulfport in 1945 and sold juice, fruits, candy, cigarettes, and ice cream. Trolley conductors never failed to stop between runs for a cool drink of her hand-squeezed orange juice.

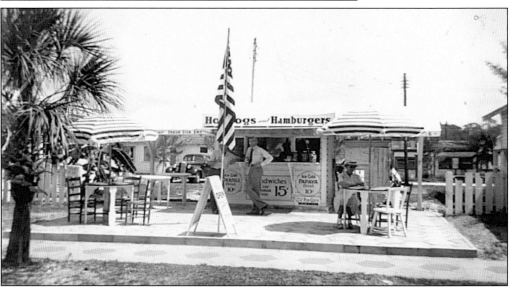

Just around the corner, this hamburger stand was in its heyday on Shore Boulevard in the early 1940s. You could have your choice of a fish fry, burger, or hot dog for 15¢, and you could wash it down with papaya juice for just another dime.

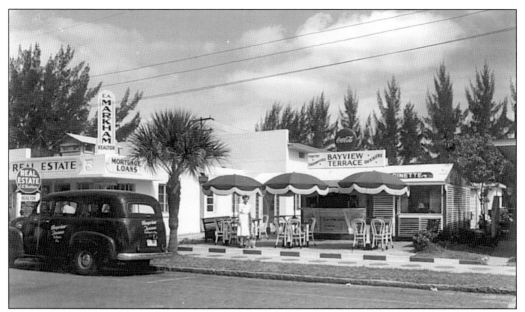

In 1947, the hamburger stand became the Bayview Terrace and continued to offer a fish sandwich so popular that people came from miles away to enjoy it. The fish was fresh from Aylesworth's Market and the juice came from Phoebe Arms. Casino dancers came across the street for a snack here during intermissions. The car is a 1948 Suburban bought to carry supplies.

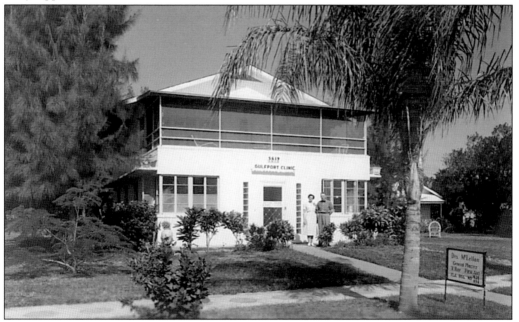

To the west, along Shore Boulevard, Drs. Colin and Grace McLellan opened a new medical clinic. They were naturopathic physicians who had many other interests in the community. Dr. Colin loved sailing and softball and helped start the Boomerangs. It was a ball club for senior men, but almost anyone who showed up was allowed to play, provided they were over the age of 12.

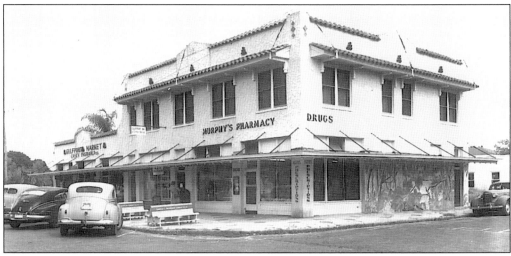

Up in Beach Boulevard's business district, the Pharmacy was purchased by Merton Murphy and the adjacent market by Casey Ingram. Gulfport's resident artist, Richard Gray painted a beautiful mural on the south side of the building, and many people came to town just to be photographed in front of it. The mural disappeared under a repainting of the building sometime around 1960.

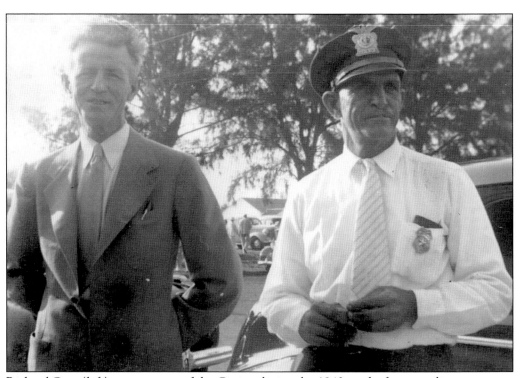

Richard Gray (left) was manager of the Casino during the 1940s and a fine muralist, as seen on the Pharmacy building. Two of his paintings still hang in the Casino, and one is on exhibit at the historical museum. Gray is seen here with Police Chief Lloyd Holland, who was known by all as "Mout," for frequently saying, "I mout lock you up or I mout not."

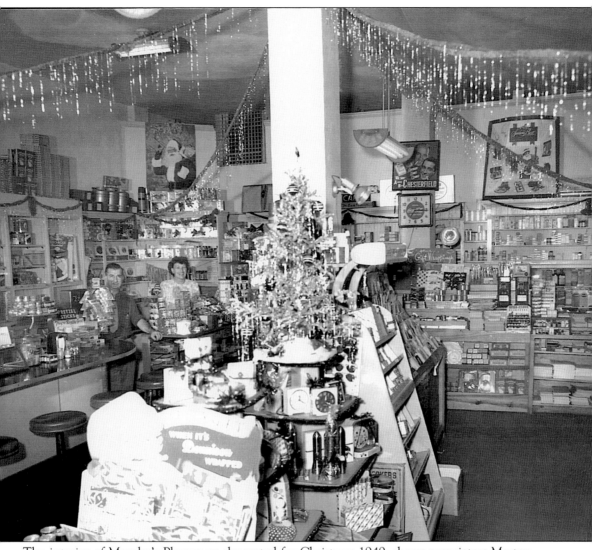

The interior of Murphy's Pharmacy, decorated for Christmas 1949, shows proprietors Merton and Althea Murphy behind the counter. In addition to filling the town's prescriptions, Mr. Murphy became the "Doc" to many local fishing families who saw no reason to go elsewhere for medical advice or treatment.

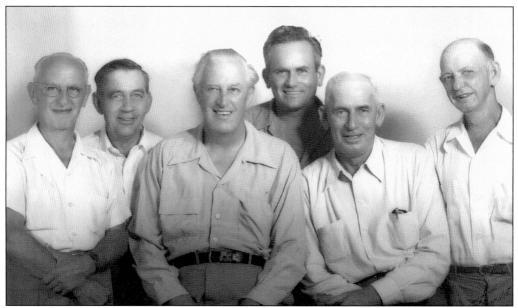

The Gulfport City Council poses after their election in 1948. From left to right, they are Adolph Weis, Archie Tabor, Mayor Clifford Hadley, Council President Edward Hatmaker, Walt Williams, and Walter Roberts. Mayor Hadley, the naval architect, was serving his second term, 14 years after his first. Walt Williams had preceded him as mayor and would follow him as well.

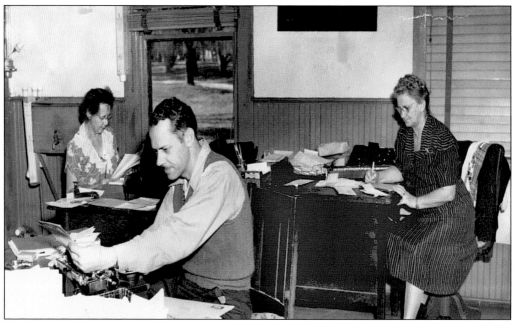

At city hall, Clerk John Holsapple (seen here in the foreground) was in the middle of his 28-year tenure in that position, which he would hold even after the town became a city and adopted the council/manager form of government in 1955. The staff clerks were Mrs. Stubbins, (left) and Mrs. Ethel White, daughter of Nathan McKinney, one of the town's early mayors. (Courtesy of Nathan White.)

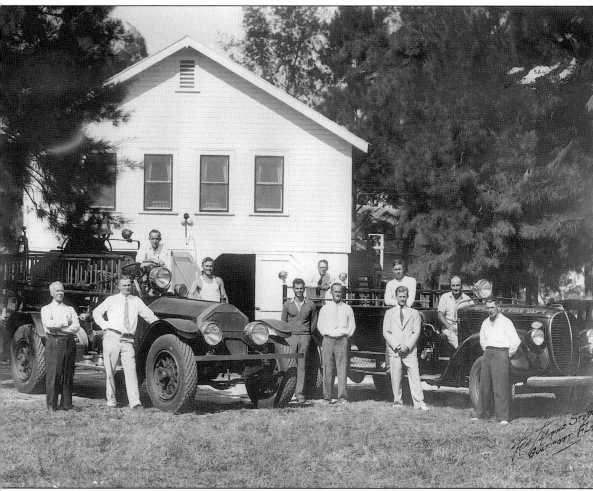

Many of Gulfport's families were represented on the volunteer fire department. Shown here are members posing with their engines, the 1925 American LaFrance (left) and the 1939 Ford Peter Pirsch. From left to right are as follows: (front row) Lester M. Wintersgill, Jerome Girard, Mert Barrs, Reese Whitworth, Malcolm Whitworth, and "Frenchy" LaJoie; (back row) Howard Hayes, George Landers, Mack Brooks, Johnny Hudson, and Norman Huckins. Brooks, who served as chief during this period, was the son of former chief Walter Brooks, and the father of the present chief Brian Brooks. (Courtesy of Gulfport Fire Department.)

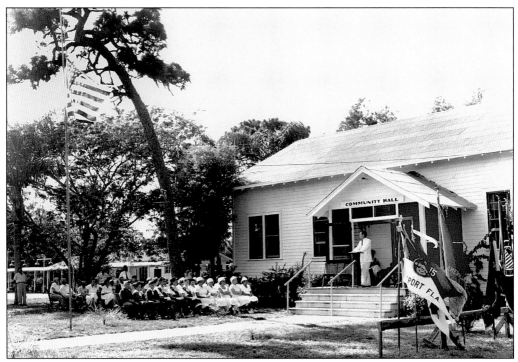

The Boy Scouts share a Fourth of July program at Scout Hall with the American Legion and other civic organizations. In the background can be seen the shuffleboard courts, which had been moved up to Chase Park from their original location on the waterfront.

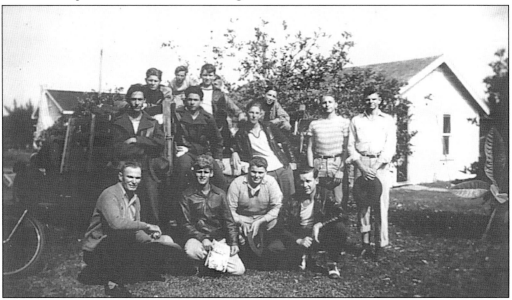

Scoutmaster Jerome Girard, sitting at the left, gathers Troop 15 to prepare for a trip to the County Fair. Also seated is Terrence "T-Bone" Wood, between two unidentified boys. Standing, from left to right, are Danny Berry, unidentified, Howard Girard, Buddy Johnson, and Robert Huff. At the far back are Stuart Huff and three other unidentified boys. (Courtesy of Nathan White.)

Playing dress-up for the Gay Nineties Festival in January 1948 are Mayor Walter Williams, Mrs. Edna Christman, and Louis J. Boeri. Antique car shows, which are still held annually today, seem to have been a favorite event in Gulfport for over half a century.

Just about as soon as Little League came into existence, the games of baseball and softball, played informally here for years, became organized youth sports. In this photo, a group of unidentified young men and their coach, described as one of the town's first baseball teams, stand ready to begin the 1949 season.

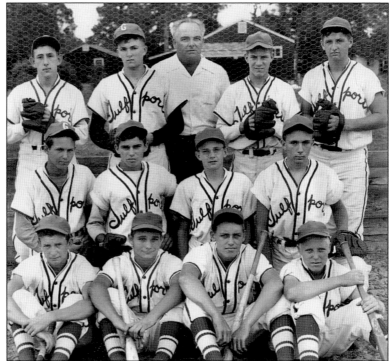

At midnight on May 9, 1949, the old streetcar made its last run to Gulfport. Wartime had been great for business with so many servicemen stationed in the area, and the line had made more money than at any other time in its history. But soon afterward, the passenger load dropped; bridges were open and cars were on the road. Greeted by Mayor Hadley and serenaded by a barbershop quartet from the steps of the Casino, the last trolley in Pinellas County—and in all of Florida—passed into history.

Six

1950–1960

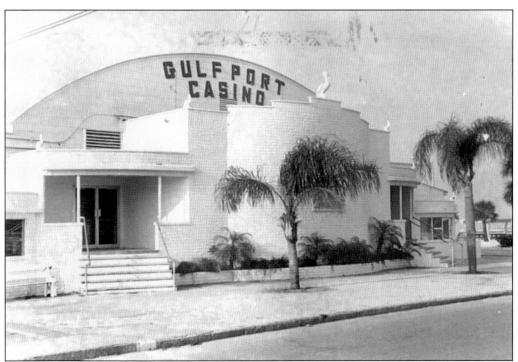

In 1950, the Casino was completely renovated. The stage was moved from the south end into a newly constructed bandshell that had been added at the front of the building. Around 1958, the dance floor was enlarged, air conditioning was added, and some much needed repairs were made to the leaky roof. The facade remains unchanged to this day, awaiting one more proposed renovation of the city's most historic building.

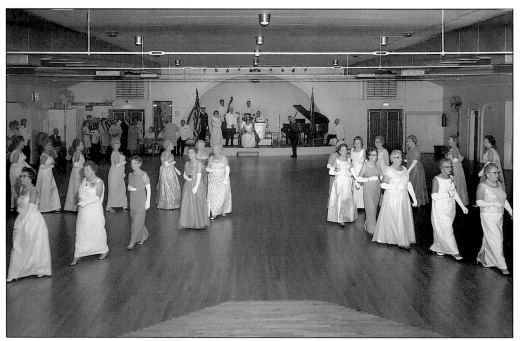

Formally dressed ladies grace the Casino's famous dance floor at a 1950s ball. The new bandshell at the front of the building provides just the right amount of space for a small orchestra.

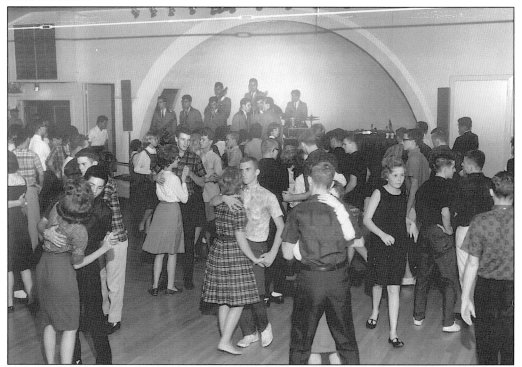

On another night, the lights are dimmed, attire is casual, and a swing band takes the stage to play for a teen hop sponsored by the Chamber of Commerce in 1953.

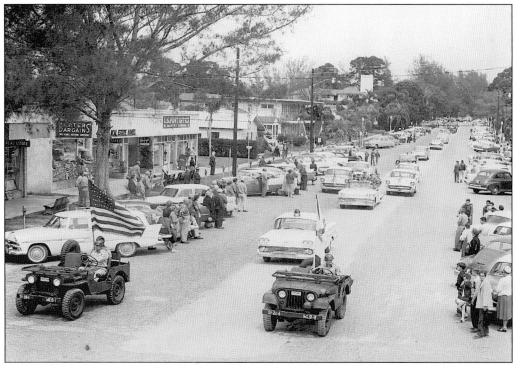

The Gulfport Lions Club was chartered in 1948 with a membership representing business, professional, and civic leaders. During the 1950s, the club sponsored "Gala Days," an annual week-long festival of parades, dances, beauty contests, and land and water events to support their charitable work. Here is a view of one of their parades, looking north on Beach Boulevard from the Casino.

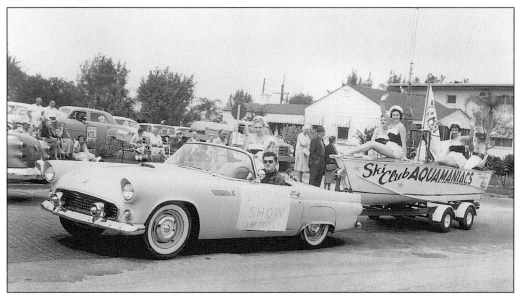

The Ski Club Aquamaniacs advertise their "Big Ski Show" in the 1958 Gala Days parade. In this photo, as in the previous photo, one can see the patching down of the center of the brick boulevard, where the trolley track once ran.

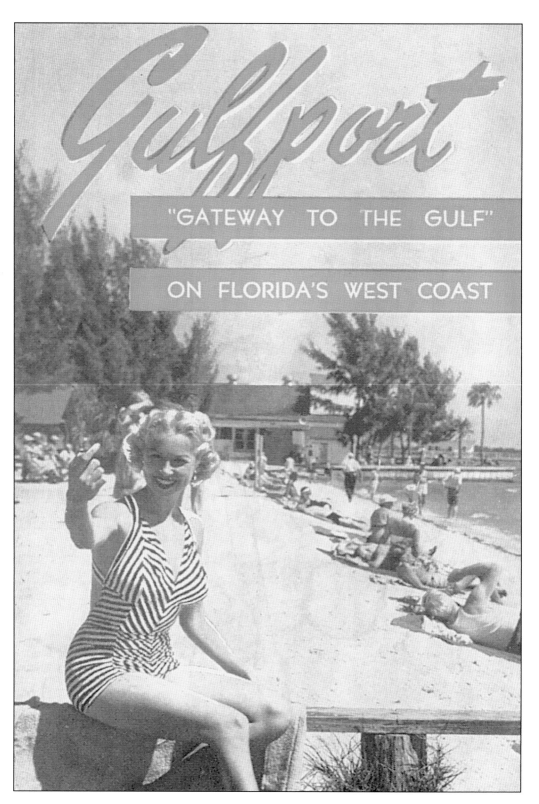

Gulfport

"GATEWAY TO THE GULF"

ON FLORIDA'S WEST COAST

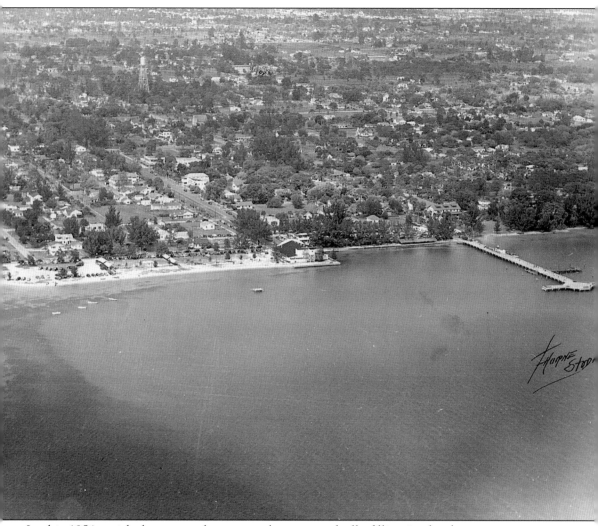

In this 1954 aerial photo, new homes can be seen gradually filling in the downtown area. The pier continued to be a social hub of the community, for even as commercial fishing had dwindled, pleasure boating and fishing had grown in economic importance.

Opposite page: A new brochure beckoned visitors to Gulfport, "where June-like weather prevails the year-around." But now the trend was toward attracting residents to "a splendid place to live," as home building again surged to meet the demand of young families. Schools, homes, and churches have become a greater draw than the vacation activities of the previous brochure.

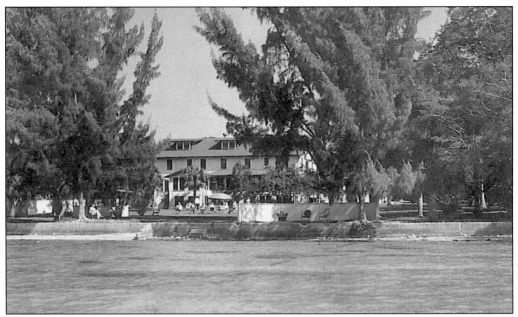

Under the management of Paul Camp Jr., the Boca Ciega Inn continued to attract visitors although business was not the same as in earlier days when wealthy vacationers came for the entire winter. The stays were shorter in the 1950s, and the guests required more entertainment. The back of this card advertises, among other thing, a television lounge.

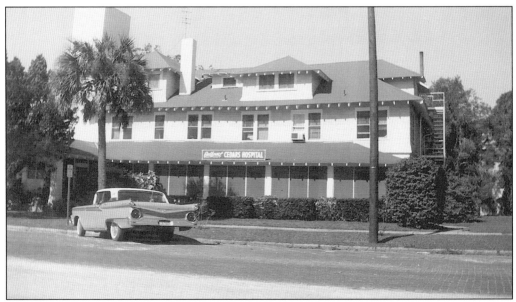

The Bay View Hotel, on the other hand, had gone out of business. About 1950, the hotel became a hospital known as the Cedars, and to accommodate patients, an elevator and outside fire escape were added to the building, which was otherwise little changed from its original appearance. When state regulations required masonry construction for hospitals in 1964, the Cedars became a nursing and convalescent home.

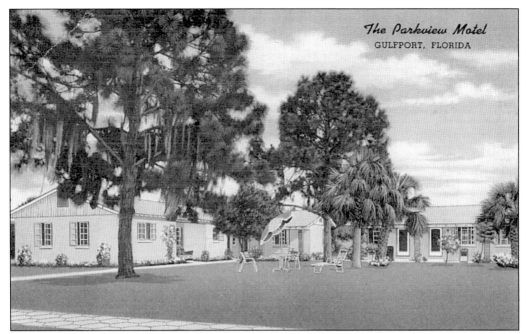

The Parkview Motel
GULFPORT, FLORIDA

Catering more to the modern tourist was the new Parkview Motel at the corner of Beach Boulevard and Twenty-eighth Avenue. Built around the beginning of the decade, it is still in use as a motel.

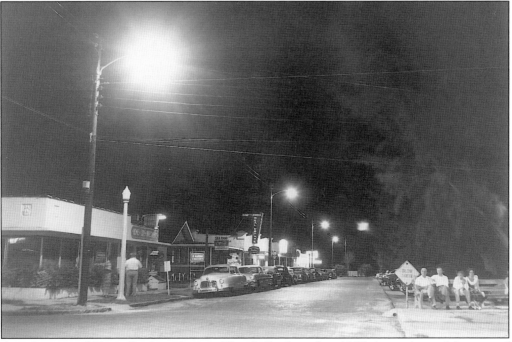

A night view of Shore Boulevard east of Beach Boulevard in 1955 shows the proliferation of real estate offices, as Gulfport enters its second building boom. The old acorn-top lampposts, as seen at the left, were being replaced by modern high-power lights. In the late 1990s, the old-style lamps were once again installed in the historic waterfront district.

The R.W. Caldwell Real Estate office was located in the beach area from 1937 until 1953, when it moved to this new building on Gulfport Boulevard, where it remains today. Caldwell's is the oldest non-franchise real estate company continuously operated by the same family in the St. Petersburg area.

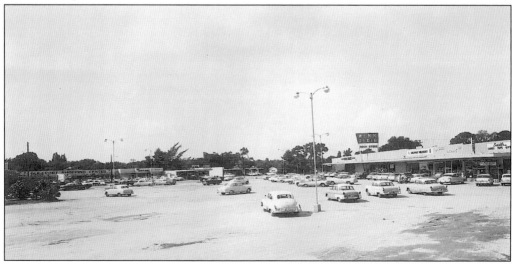

Spreading the business district even farther northward, a new shopping center opened in the 1950s at Forty-ninth Street and Gulfport Boulevard. Then, as now, the Winn Dixie grocery store was the center's anchor tenant.

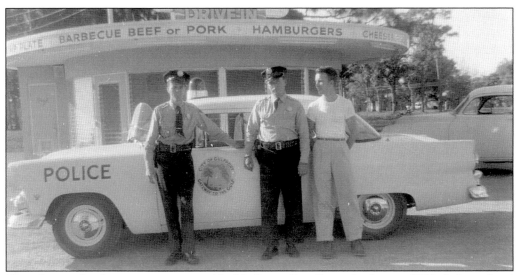

Next door to the shopping center stood Jack's Seven Seas Drive-In. In true 1950s fashion, local girls served as carhops, and the police, seen here with proprietor Jack Thayer, often stopped by for a snack.

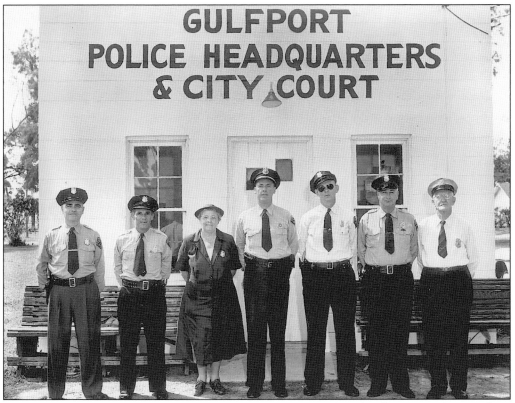

The members of the Gulfport Police Department pose outside their headquarters. They are, from left to right, Officers Gilbert and Sherrill, Mrs. Christianson, Officers Sanborn and Vincent, Chief Jopson, and Officer Jurisak. Gulfport still had its own municipal court, as seen on the sign, but its days were numbered.

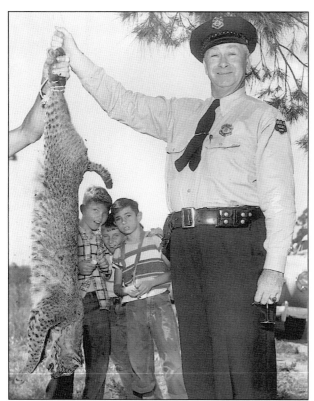

Chief Bill Jopson is obviously proud of catching this bobcat, and the neighborhood kids are in awe. Forty or fifty years later we find it hard to accept the fact that this was not an uncommon occurrence.

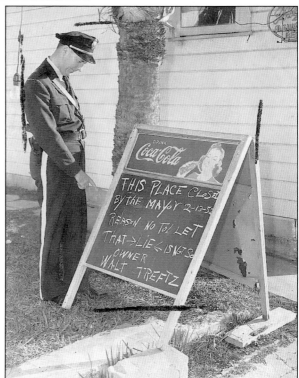

In another police action (and one probably not that rare, either), Officer Sandy Sanborn enforces the closing of a "joint" in 1952. The owner apparently protested.

City hall had a new home in this 1953 building on Fifty-third Street. Constructed with city labor for a cost of only $17,000, the building was dedicated on November 7th, the same day the old 1913 city hall was auctioned off for $150. This structure lasted until 1994, when another building went up directly behind it; the old building was subsequently demolished.

G.P.3:-GULFPORT PUBLIC LIBRARY, GULFPORT, FLORIDA.

The library continued to expand when a new wing was added in 1956. The City had recently adopted the council/manager form of government and had appointed a Library Advisory Board to take over financial responsibility. With the growing population, the inadequacy of this facility was recognized and a move was begun to acquire land and raise funds for a new building.

The 1912 Methodist church, the town's first house of worship, had become too small for its growing congregation. Rather than destroy the historic structure, officials had the foresight to move it across the street, into Chase Park. It was first used by the Boy and Girl Scouts and then for a variety of other civic purposes, including the Red Cross, until it was acquired by the historical society in the early 1980s.

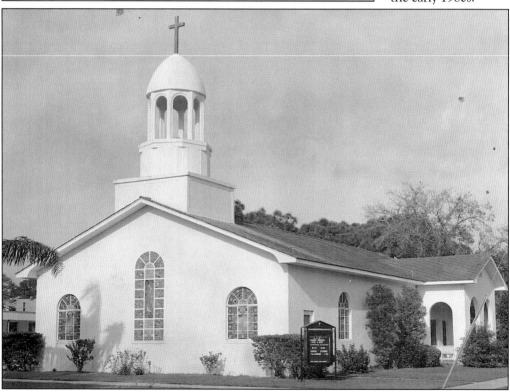

In 1951, ground was broken for the new Methodist church sanctuary on the corner of Fifty-third Street and Twenty-eighth Avenue. Roy Pippin was the contractor for the new building and for the education annex that followed in 1956, after the removal of the old church to Chase Park. Later, an entrance was added in this western wall. The Reverend Elsie Davies was the congregation's much-admired pastor during this period.

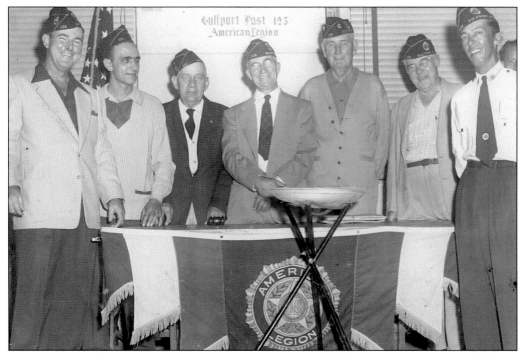

Gulfport Post 125 of the American Legion was chartered in 1941 and moved into its home on Forty-ninth Street, where the group continued their work for the community in many civic, educational, and athletic projects. Here, shown burning the mortgage on the clubhouse in 1953, are W.T. Sharp, Harold Mann, Archie Tabor, Andrew Potter, Captain Earl McMillen, Harold Robbins, and Neal Walker.

The American Legion Auxiliary received national recognition for their fine work in 1954. Some of these women have been identified. They are, from left to right, as follows: (front row) Thelma Willoughby, Ruth Taunton, Myrtice Blydenburgh, and four unidentified ladies; (second row) Mrs. Archie Tabor, three unidentified ladies, Stella Moulton Tamm, and Mrs. Landers. The lady in back (center) is Lucille Jellison.

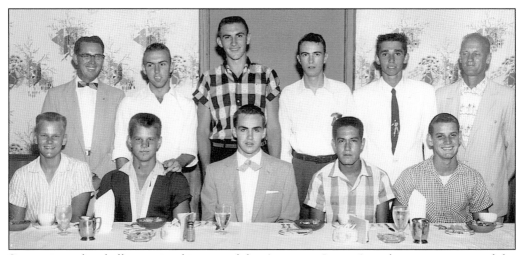

Sponsoring a baseball team is a big part of the American Legion's enthusiastic support of the city's youth. Seen here at a dinner in 1958, the team is flanked by two men who contributed years of volunteer service to this endeavor: (left) manager Arnold White and (right) coach Lawrence T. McCarthy.

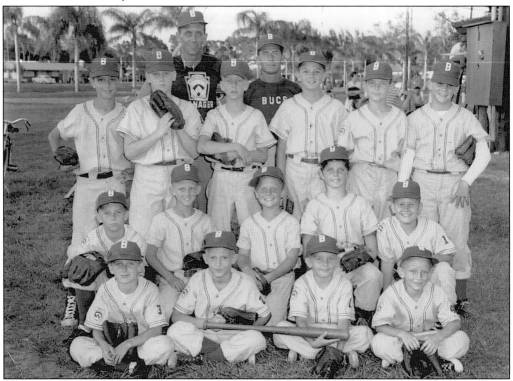

Younger children got to play in the Little League system. This picture of a late 1950s team shows the following, from left to right: (front row) Jeff Hines, unidentified, Jim McLane, and Alan Clutterbuck; (middle row) Jay McLane, ? Frohoch, Lloyd Hankinson, Bobby Worthington, and Harry O'Brien; (back row) Buddy Fisher, Bobby Jackson, ? Frohoch, Roney Kirby, Reggie Kirby, and Jackie Wilson. Lum Atkinson is the manager, and Leon McLane the coach. (Courtesy of the Worthington family.)

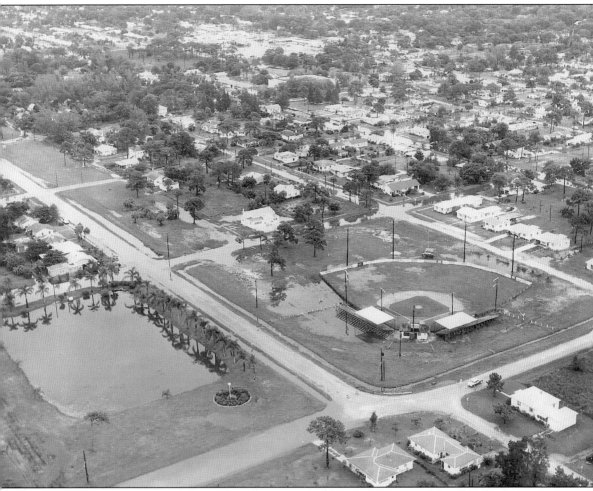

This is a 1957 aerial view of the new Little League field at Tangerine and Beach, which was developed with help from the Lions Club and the city council. At about the same time, the drainage pond was created just north of the park. Gulfport's synagogue is the white building in the center, immediately east of the baseball field. This is the turn-of-the-century location of Singlehurst's sawmill, inside the corner where the trolley curved south on Beach Boulevard from Tangerine.

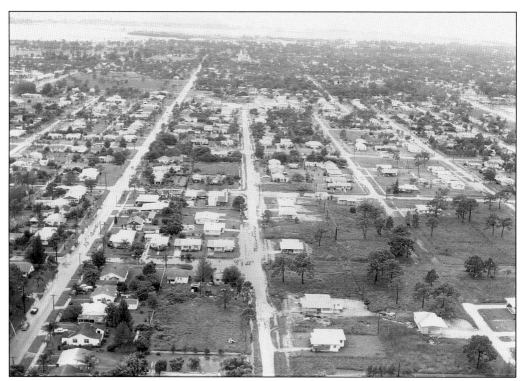

Another aerial view from the same time looks west on Fifteenth Avenue, this time showing the 1950s boom in building small Florida homes for postwar families. The neat grid of blocks has been there for a long time; now it is filling up. In the distance (at the top) can be seen the old Florida Military Academy buildings, which were recently acquired by Stetson Law School.

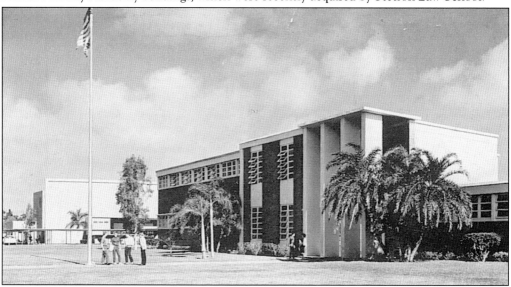

To serve the children of all these new citizens, Boca Ciega High School opened in September 1953, with 43 classrooms in 5 wings and a capacity of over 2,200 students. It was the first new high school built in Pinellas County since the 1920s boom times. Located at the northern limits of the city on Fifty-eighth Street, it drew students from Gulfport and surrounding areas.

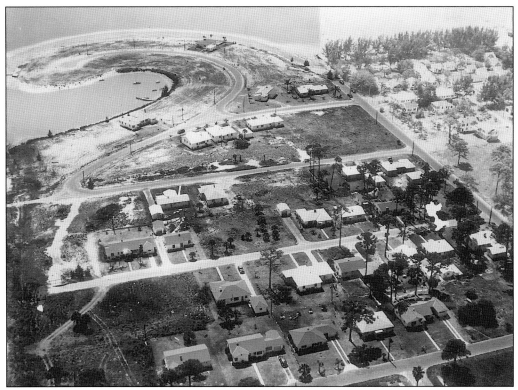

In the southeast part of town, Baywood Point is beginning to be built up, too. The land dredged up in the 1940s, as seen on page 81, will soon be covered with brand-new homes.

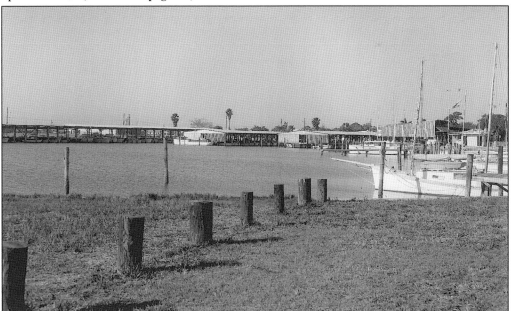

Immediately east of Baywood Point, the Marina is becoming a modern facility for docking boats. The channel was deepened, range lights were installed, and new sea walls were built. By the end of the decade, there were 120 covered boat slips.

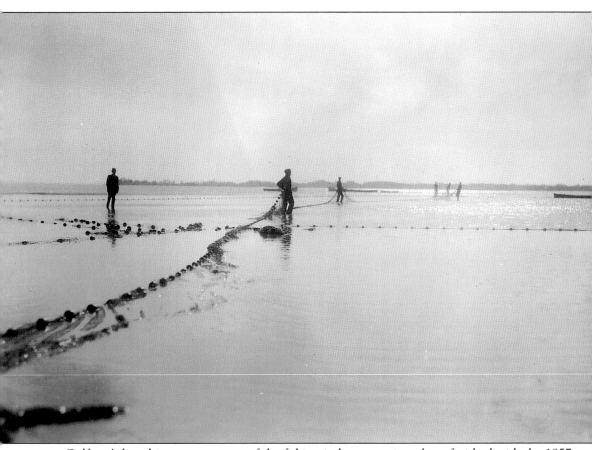

Gulfport's long history as a center of the fishing industry was just about finished with the 1957 legislation against stop netting. The debate had begun in the 1940s, when much of the water was closed to netting due to the war, and a movement began to deny its resumption. The fishermen prevailed at that time, and netting again provided for the shipping of some 5 million pounds out of the Clam Bayou's fish houses each year. In 1957, the era is finally over for good as these men lay some of the last nets ever seen in the bay.

Seven

AFTER 1960

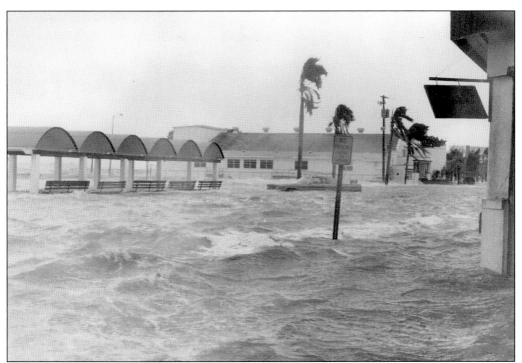

Although only once, in 1921, did Gulfport suffer a direct hit by a hurricane, many storms have caused serious flooding in the low-lying waterfront area. Here, the June 1982 "no-name" storm has swept water up the beach, filled Shore Boulevard, and reached the downtown streets. Sand had been dredged to fill in under the Casino so that it now sat on dry land (until a storm like this came along).

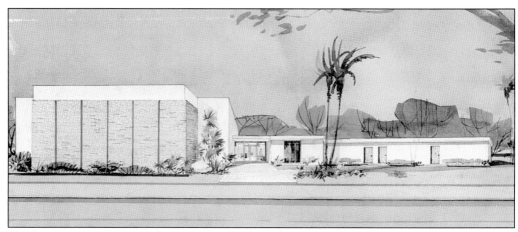

The beach area saw a great change in 1965, when plans were made for a new community center to be built on the shore at the foot of Fifty-eighth Street. This architect's drawing shows the building's original appearance, which remained much the same until a complete renovation was begun in 1997.

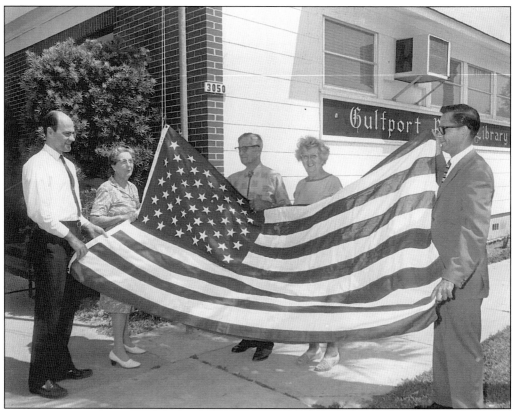

Also in 1965, the library celebrated its 30th year of operation. Mr. and Mrs. Andrew Potter, Mayor John Robinson, Librarian Marie Bryan, and City Manager Nicholas Meiszer raise a flag brought from the Capitol Building in Washington to celebrate. In 1976, a brand-new building would be constructed on the green space where the trolley tracks once ran, just north of Twenty-eighth Avenue.

Lawrence T. "Mac" McCarthy, seen here in 1962, served the city in many capacities. He was the director of Public Works, fire chief, and acting city manager at various times during his career. He also served on the firefighters pension and historical society boards and coached Little League. The new Fire Administration Building was named in his honor at its dedication in 1976.

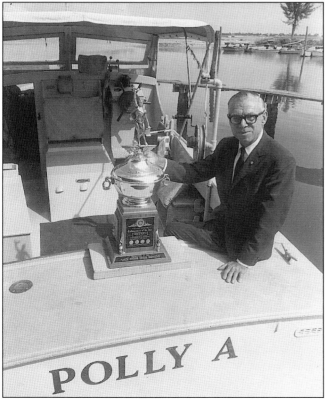

In this 1967 view, "Andy" Anderson is shown aboard his boat, the *Polly A.*, with a trophy awarded him as "Outdoorsman of the Year" by the Outdoor Writers Association. Anderson served as mayor of Gulfport in the mid-1950s. During his term in office, he drafted the city's charter.

117

In the 1960s, developers began to look seriously at the old "Fiddler's Flats" mangrove marsh to the west of the beach. Here, Don Simonds and a friend are dove hunting; they were some of the last to do so before the land was sea-walled and filled in.

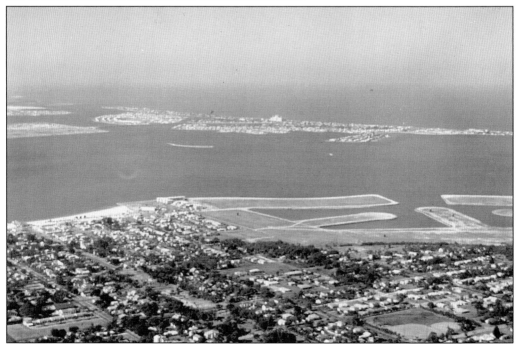

The old town dump on the tidal flats, once owned by Dixie Hollins, was prepared for building in the 1960s. St. Petersburg Beach, with its landmark hotel, the Don Cesar, can be seen in the background, across Boca Ciega Bay.

118

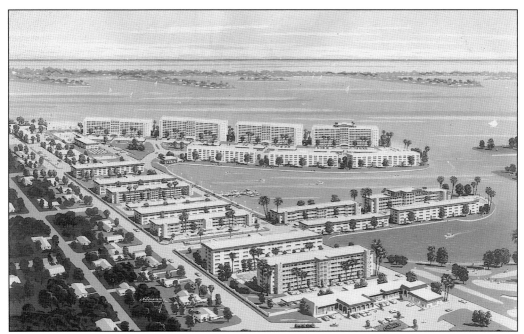

The Town Shores Condominium Complex, seen in this architectural rendering, provided 1,340 new apartments, which could be purchased for as low as $12,000 in 1970. In addition to its many other advantages to the community, this replacement of the old tidal swamp eliminated much of the mosquito population.

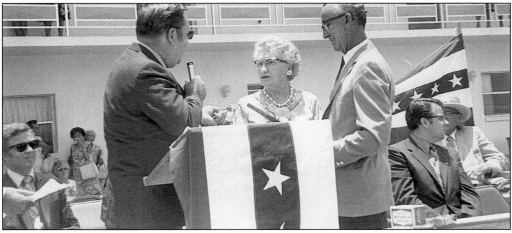

Mayor Bud Markham presents a gold key to a Mr. and Mrs. Smith, the first tenants of Town Shores, at the Ribbon Cutting Ceremonies in March 1970.

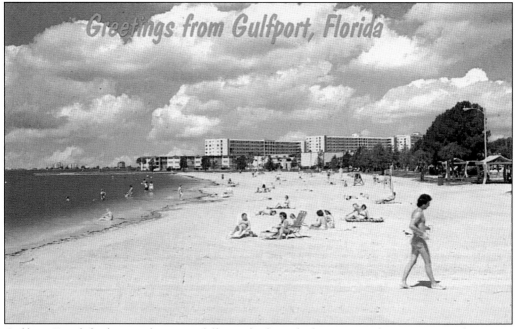

Greetings from Gulfport, Florida

Gulfport Beach had now taken on a different look, with the new condominium complex rising in the background.

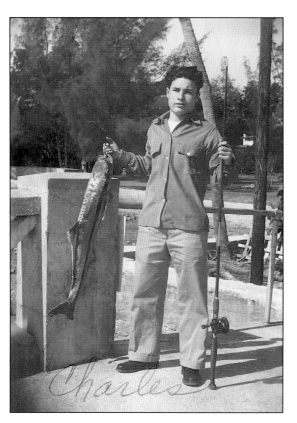

Charles

After retiring as a New York cab driver, photographer Morris Rubin came to Gulfport in 1934 and set up his "Picture in a Minute" business on the beach. Rubin used a camera he had invented to produce a direct positive image. He worked there daily until 1979, charging 25¢ for a picture such as this one of Charles Worthington, who is shown posing with one of Rubin's famous prop fish. (Courtesy of Worthington family.)

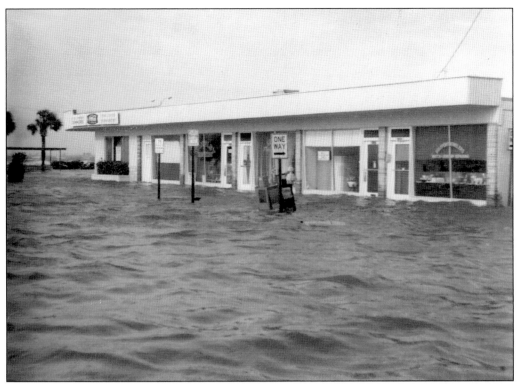

The huge Hurricane Agnes passed within 150 miles west of Gulfport in 1972 and caused major flooding, as seen in this photo of the last block of Beach Boulevard entirely filled with water. With one-third of the city's area at less than ten feet of elevation and almost nine miles of coastal shoreline, Gulfport has been extremely lucky to avoid more serious damage throughout its long history.

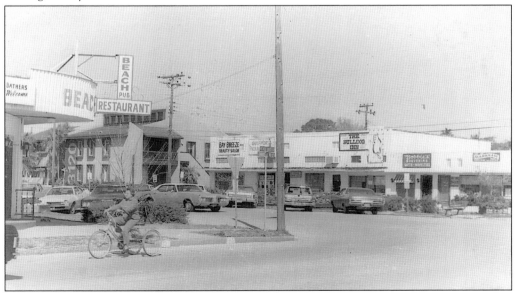

Not one of Gulfport's best decades, the 1970s saw the downtown area become somewhat run-down, as illustrated by this 1977 photo of the corner of Beach and Shore Boulevards.

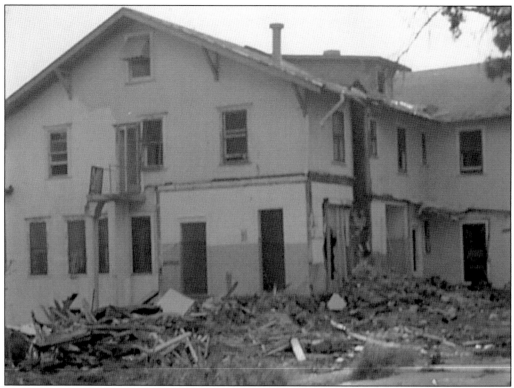

Two major landmarks were lost in the 1970s. First to go was the Boca Ciega Inn, demolished in 1974. Closed since 1968, the building had stood vacant and unattended, a magnet for vandals. An apartment complex was intended for the site, but never materialized, and the City eventually acquired the land and created a beautiful new waterfront park memorializing Gulfport's veterans.

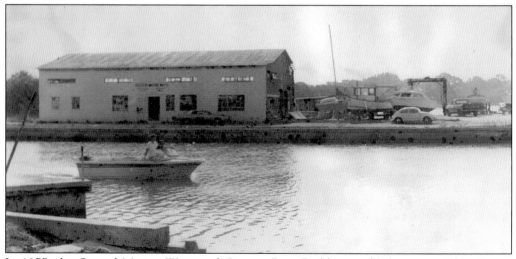

In 1977, the Osgood Marine Ways and Custom Boat Builders establishment at Clam Bayou closed for good. A 1956 fire had destroyed the original business, but Neil Osgood had rebuilt a metal shop and mobile boat lift and continued to serve boaters until his retirement. Here, too, the area degenerated into an eroding, garbage-covered dump.

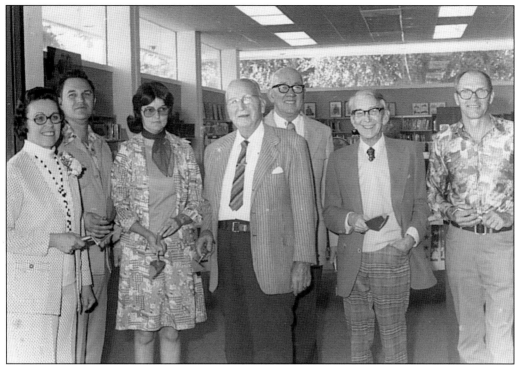

City council members dressed for the 1970s pose after a ceremony at the new library. From left to right are Councilwoman Yvonne Johnson (mayor 1985–1987), City Manager Harry Perkins, Councilwoman Judy Tonkin, Jay P. Clymer (mayor 1973–1985), Councilman Bert Williams (mayor 1987–1991 and son of former mayor Walter Williams), Councilman Fred Allen, and an unidentified onlooker.

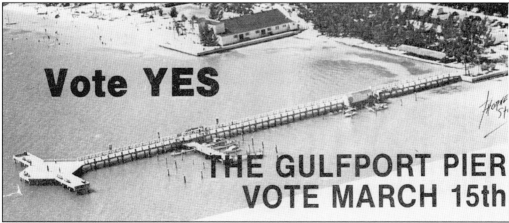

A very large political issue of the early 1980s was the replacement of the old 1930s pier, which was removed in 1982 when it was found to be unsafe. Civic leaders, business people, and descendants of the early families rallied during this campaign to convince newcomers to the community to vote financial support for the building of a new pier. They won, and the present pier was soon constructed.

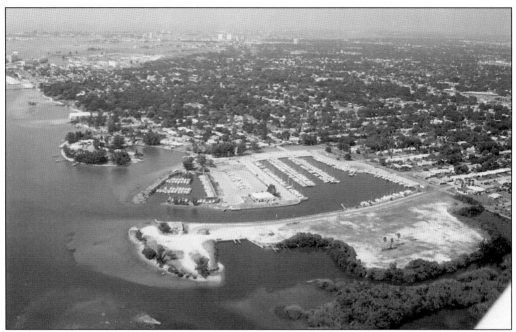

Osgood Point, seen in the foreground, was cleared of all the old fish houses and boat building establishments by 1980. The City began looking for uses for the area and advertised it for lease, proposing to create a commercial development. Residents objected and in the early 1990s, city and state agencies combined to create a new passive park and natural habitat under the old Clam Bayou name.

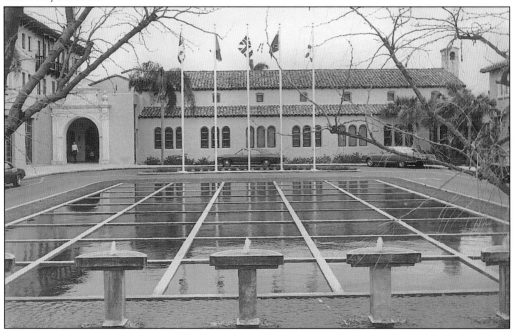

Stetson Law School continued to be a good neighbor in the northwest section of Gulfport, preserving the beauties of the old Rolyat Hotel within its campus. Here, the reflecting pool stands before the five flags under which Florida has served.

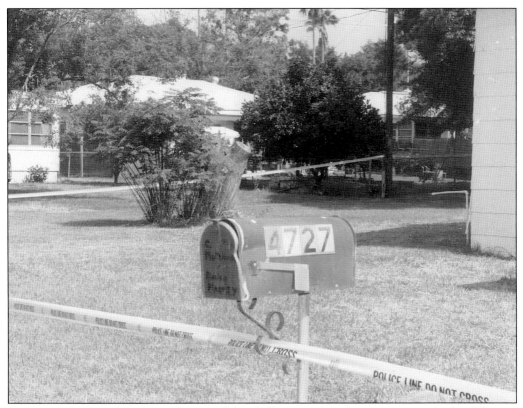

In 1984, a Gulfport home was the site of the chilling murder of a young artist. Author Thomas French followed his series of articles for the *St. Petersburg Times* with *Unanswered Cries*, a book described as "a true story of friends, neighbors, and cold-blooded murder." The lives of all involved (the detective, the murderer, and the victims) were intertwined as could only happen in a close community such as this. (Courtesy of Gulfport Police Department.)

This last look at the Tangerine Avenue greenway, where once the streetcar entered Gulfport, shows the new focal point for improvements to the northeast part of the city. With the streetscaping of the Waterfront Redevelopment District now completed, the attention of city officials has turned to this latest project.

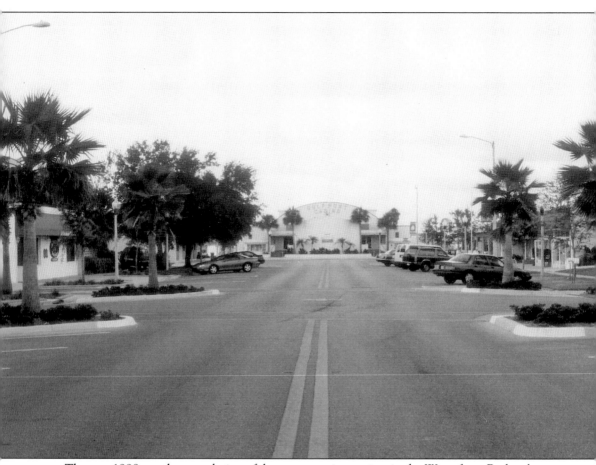

The year 1998 saw the completion of the streetscaping project in the Waterfront Redevelopment District. Brick crosswalks, historic lighting, and new trees now grace the view down Beach Boulevard toward the Casino, which stands, as it has, for so many years, at the heart of Gulfport. (Courtesy of City of Gulfport.)

INDEX